Picturing People
for Pleasure & Profit

Picturing People
for Pleasure & Profit

JOHN WADE

BFP BFP BOOKS London

British Library Cataloguing in Publication Data:
Wade, John, *1945–*
 Picturing people for pleasure & profit.
 1. Photography—Portraits
 I. Title
 778.9′2 TR575

 ISBN 0-907297-06-4

First published 1985

BFP Pleasure & Profit Series
Editors: John Tracy
 Stewart Gibson

Published by BFP Books, Focus House, 497 Green Lanes, London N13 4BP.
Printed and bound in Great Britain by Burgess & Son (Abingdon) Ltd.

CONTENTS

Introduction

People pictures are where most of us start. Long before we consider ourselves to be serious photographers, amateur or professional, somewhere along the line we all take pictures of people.

People on holiday, people at family occasions, people in groups, people alone. Candid shots of aunts and uncles asleep in deckchairs; stiffly-posed relatives, self-consciously waiting for the shutter to click; cheeky children mocking the camera. People pictures are at the very heart of the good old snapshot that leads so many into the exciting world of amateur and professional photography.

If the bug bites and you move on from snapshots, it isn't long before you start to look at your pictures in a new light. Suddenly, you're trying to do something more creative with your pictures. You don't just 'snap' people, you deliberately pose them, looking at lighting and backgrounds, bringing some atmosphere to your photographs. After that, you might start to look round for something to actually *do* with your pictures. Maybe you send them to exhibitions; perhaps you've joined a camera club and you enter them into regular competitions; eventually you come round to selling your work.

Photography can be an expensive hobby; it's an even more expensive profession. Selling some of your pictures will help to offset the expense. Do it well and you'll come out at the end of the day with a profit. It's the way amateur photographers suddenly find they've turned into professionals.

That's what this book is all about. Within these pages we're going to look at ways of taking saleable pictures of people, where to sell them and how.

There are many different types of people pictures, but they all have one thing in common. The people themselves are bringing to the picture a certain amount of human interest. It might be to a large degree as in a formal portrait, or it might be to a far lesser extent, using a person, for instance, as a key point in a landscape. But whatever the degree of involvement, human interest is one of the biggest contributions to the success of saleable pictures.

The market for people pictures is huge – from babies in nursing magazines to pin-ups on glamour calendars, from personalities in newspapers to portraiture in the subject's own home.

The standard portrait approach to people. The techniques are easy to master and give you a good base from which to produce pictures that sell to many different markets.

You can sell people pictures direct to the subjects themselves and you can sell them for publication. Newspapers, both local and national, thrive on pictures of people in the news, while magazines in the market for your work can include all types from general to specialist interest and from those aimed specifically at women to others catering exclusively for men. The vast majority of magazines use people pictures on their covers: Glamour, beauty, hobbyists at work, theatrical shots, posed and unposed, the famous and the infamous . . . they all appear on magazine covers and they're all people.

Then there's greetings cards and calendars, two markets that are similar in many ways, and both of which use a lot of people

pictures. There's travel brochures, showing people enjoying themselves on holiday and book illustrations that use pictures of people involved in just about any subject under the sun.

You can market your pictures yourself, or you can use an agent. Look through the files of most picture agencies and you'll find a lot of people doing a lot of different things. Would you have thought you might be able to sell a picture of your own very ordinary family doing nothing more than sitting watching television? It's the sort of subject that picture libraries are often desperate for and, with so many photographers setting out to take the exotic and unusual, they just haven't got enough 'ordinary' pictures to go around.

Then there's photo contests. Speak to any competition judge and he'll tell you that it's the human interest – the people – that make so many of the winning pictures worthwhile. And pictures that win can be very profitable to the freelance photographer.

Okay. So you're raring to go. Where do you start? Funnily enough, you don't start with the pictures. If you're an old hand at freelance photography, you'll be well aware of this, but if you're new to the game, a statement like that might seem a little strange.

Another way to sell people is to use them as part of the landscape.

The biggest mistake any potential freelance photographer can make is to take a set of pictures and then look round for a market.

Sometimes he'll strike lucky, but more often than not, he'll fail to sell. The point is that every market is highly individual. Each has its own set of standards and requirements, and if you are going to sell to that market, you have to supply exactly what they want.

So don't start with the pictures. Start with the market.

Look round for the type of market to which you wish to sell. Choose it carefully, looking for one that uses the type of pictures that you like to take. Then go out and shoot pictures *with that market and that market only in mind*. Working this way greatly enhances your chances of success.

One ready-made way to find a suitable place to sell your pictures is to subscribe to the Market Newsletter published monthly by the Bureau of Freelance Photographers. BFP Books also publish a very useful book called *The Freelance Photographer's Market Handbook*. In it, you'll find detailed information on over 600 markets for your pictures, with names to contact and words about what they're looking for.

Whatever market you choose, it's essential to get to know it inside out. If you've chosen a certain magazine, for instance (and notice, we're talking about a specific *magazine*, not merely a specific *type*), you should buy several copies and read them from cover to cover.

There are over 7,500 magazines published in the UK and the vast majority of them use people in some form on their covers.

That way you'll get to know the type of people it's aimed at and the sort of pictures it regularly uses. You'll soon come to realise that what's absolutely right for one magazine can be disastrously wrong for another. The type of jokey, off-beat pictures that might sell to a popular general interest magazine would never sell to an upmarket society magazine. The blurred, but exclusive picture of a pop star that might sell to a music magazine wouldn't stand a chance in a glossy women's magazine. It's horses for courses all the way.

This book is divided into two basic sections. First you'll learn how to *take* better pictures of people and then, in the second half of the book, you'll find details of the sort of pictures required by the many different markets, together with helpful hints on the pitfalls that you may fall into and how to avoid them. You'll find that section a great help in sorting out the market you want to aim at, but when it comes down to finding a *specific* market, there's no real substitute for personal research.

Enough said? Right, let's start taking pictures...

People are newsworthy and most of the pictures you see in your local or national newspaper involve some form of human interest.

The straightforward publishing market isn't the only profitable place for your pictures. Here's one that won a national photo contest.

Part One
THE TECHNIQUES

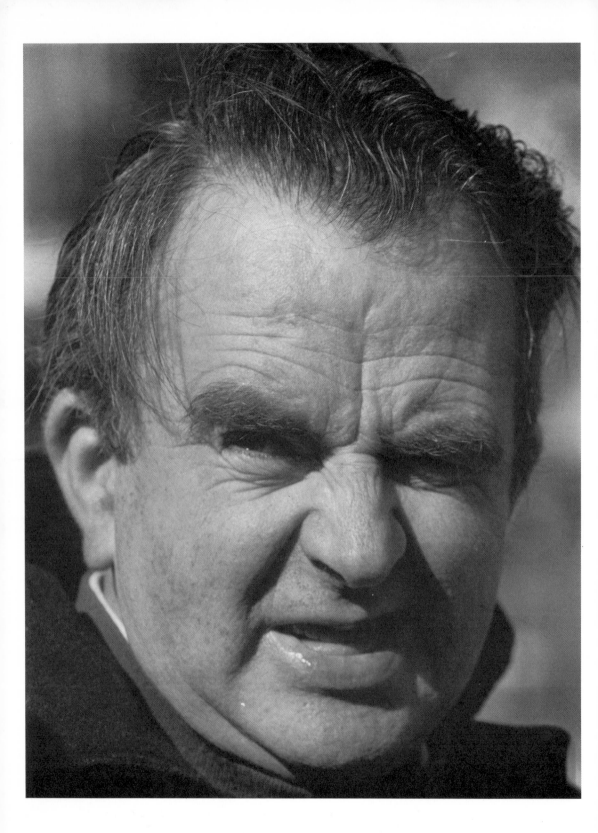

Choosing Your Equipment

You don't need a whole arsenal of cameras, lenses and other equipment to turn out successful and saleable people pictures. Certain subjects might be covered as easily with an inexpensive compact as with an expensive rollfilm SLR. However, if you are serious about freelancing – and the fact that you're reading this book at all should indicate just that – there are certain types of camera, lens, etc., that you should look towards equipping yourself with.

Cameras

The most popular format of camera is undoubtedly 35mm. There are two basic types: the compact and the single lens reflex. There's also a small minority of non-reflex 35mm cameras that are too sophisticated to be called compacts and so are something of a law unto themselves. We'll come back to those in a moment.

Compact cameras have come a long way since they were first introduced. Once thought of as no more than snapshot models, most are now extremely sophisticated pieces of electronic wizardry with every feature automated for ease of use. A typical model might offer auto exposure, auto focus, auto film wind and auto rewind, coupled with the convenience of built-in flash. With care, compacts can be used for straightforward full-length pictures of people, but they are not ideal cameras for the serious freelance. They have fixed lenses with semi-wide focal lengths, making it difficult to fill the frame with your subject, and distorting features when you do. Frame-filling is also hampered by parallax problems: the difference between the view seen by the viewfinder and the one seen by the lens, often leading to heads and feet being cropped off in the final picture. The compact is a good take-anywhere camera to keep in your pocket at times when you don't want to carry a full outfit with you, but if you are serious about photography and selling pictures, you'll be better off with a single lens reflex.

The major advantage of an SLR is the way the viewfinder allows you to look directly through the lens. What you see on the focusing screen is what you get on the picture. Also you have the ability to change lenses, and to see *their* different effects directly through the viewfinder.

You can sell all types of people pictures. This shot, taken candidly in a crowd, has made several sales to magazine and book markets.

The 35mm single lens reflex is the most popular and versatile camera on today's market. It is very useful to the freelance, but the format size can sometimes be restrictive in certain specialist markets.

All modern SLRs have built-in meters and most offer some form of automatic exposure control. There are four basic modes of automation; some cameras actually offer them all, others offer only one or a few.

Shutter priority means that you choose the shutter speed, while the camera selects the aperture. Aperture priority allows you to select the aperture, leaving the camera to select the correct shutter speed. Programmed automation means the camera selects both shutter speed and aperture. Manual leaves the choice of both in your hands, but offers advice on what the camera thinks you *should* be setting, sometimes by means of needles that match as shutter speeds and apertures are altered, other times by flashing LEDs in the viewfinder. A few SLRs also offer three different types of programmed automation: the basic one, another that favours small apertures, and a third that favours fast shutter speeds.

The successful freelance is one who is prepared for every eventuality. The best type of camera for him or her is one that offers some form of automation (shutter or aperture priority is really a matter of personal choice with most people pictures), together with manual override, so that exposures can be set by hand on occasions when the photographer knows that the camera's metering might not be totally accurate.

The non-reflex cameras mentioned earlier are closer in their sophistication to SLRs than to compacts. Unlike a compact, they take interchangeable lenses; like a compact they suffer from parallax problems. They are smaller, lighter and quieter than SLRs, but are restricted in the number of lenses available for their use. Some freelances use them all the time and swear by them, but

it is not without significance that the vast majority of successful freelance photographers rely on the good old 35mm SLR.

Moving up the format scale, you can also use a rollfilm single lens reflex. These are particularly useful to the freelance who might be looking towards specialising in markets such as calendars, greetings cards, travel brochures and even some magazines. The first two of those markets are particularly prejudiced against 35mm, and many won't even consider transparencies of less than 6 × 6 cm.

The rollfilm SLR is more expensive than its 35mm counterpart. Extra lenses are available but a *lot* more expensive than those made for 35mm. But against this added expense must be set the very real advantage of being able to break into markets that ban 35mm on sight. According to which model you buy, you have a choice of three different formats on standard 120 rollfilm: fifteen pictures 6 × 4.5 cm, twelve pictures 6 × 6 cm and ten pictures 6 × 7 cm. If the camera takes interchangeable film backs, you might also find you have the advantage of several formats on one body, plus the opportunity of being able to fit a Polaroid back to make instant pictures with your normal camera and so check lighting, poses, camera angles etc.

One way of breaking into medium format photography without the expense of a rollfilm SLR is to buy a twin lens reflex. The style is rapidly dying out and only a few are actually made today, but there are still a lot of good models available on the second-hand

The 35mm compact is a handy camera to keep with you at all times and the quality it gives is perfectly suitable for sales, even if its features are somewhat restrictive for serious freelance photography.

The medium format SLR offers the sort of picture quality that is demanded by some publishers and picture buyers, many of whom insist on a minimum format size of 6×6 cm.

market. In this type of model, the camera has two lenses, one for taking the picture, the other directly above it to show its image on a large, hooded focusing screen in the camera's top. Not being a *single* lens reflex, parallax is still a problem, but indications in the viewfinder help to overcome it. All twin lens reflexes are made to take twelve 6 × 6 cm pictures on 120 rollfilm.

The only other types of commonly-used cameras are view or studio cameras at one end of the scale and snapshot models at the other. For the average freelance, specialising in people pictures, both can be discounted.

If you are really ambitious – and rich! – you can consider a view

camera, designed for at least 5 × 4 inch cut film, but remember that these are professional cameras and you must be totally convinced that you have a need for one before paying out. For most work, you would be better off ploughing your money into a good 35mm or rollfilm SLR outfit.

Snapshot cameras include those that use 110, Disc and instant film. Except in emergencies, none is suitable for the serious freelance out to sell his work.

Lenses

When you buy your camera, it will usually come complete with standard lens. That's one of around 50mm on 35mm format or about 80mm on medium format rollfilm. You can extend your range by buying shorter focal length, wide-angle lenses or longer focal length telephoto lenses.

In general terms, switching to a lens of a different focal length has two major effects on your picture. The first is a change in magnification. As the focal length gets longer, the angle of view gets narrower and far objects are brought nearer to the camera; as the focal length gets shorter, nearby objects recede and a greater angle of view is taken in.

The other change that is evident is in perspective. Long focal length lenses appear to bunch up the foreground and background subjects, the background advancing more onto the foreground as the focal length gets longer; wide angle lenses do the reverse, the background appearing to move away from the foreground as the focal length gets shorter.

The freelance out to shoot people pictures can, ninety per cent of the time, make do with just two lenses: a standard and a medium-telephoto. A standard lens allows you to shoot three-quarters and full-length pictures of people perfectly adequately, but if you move in close to fill the frame with a head and shoulders shot, then the perspective goes awry and features look distorted: eyes appear too

Four lenses that are very useful to the freelance who wants to sell people pictures. On the left is a standard 50mm lens and an inexpensive medium-telephoto 135mm. On the right are two useful zooms—a 28–80mm and an 80–200mm.

wide apart, noses swell to unnatural proportions. To counteract this, you need a lens of at least twice the focal length of your standard: around 90mm to 100mm on 35mm or around 150mm on medium format. With a medium-tele in this range fitted, you can step back from your subject and still fill the frame, but the slight difference in perspective makes features look a lot more natural. The freelance in search of people subjects will rarely have need of a wide-angle lens, except for specialist work where distortion is to be exaggerated purposely or in circumstances where his subject is actually a landscape, the person concerned merely adding a fairly distant point of interest to the overall scene. Likewise, he will have little use for a lens of more than 200mm, except, again, for some specialist effect, or unless he aims to do a lot of candid photography from a safe distance. In this latter case, anything up to 500mm on a 35mm camera might be considered.

In talking about these lenses, we have been talking essentially about fixed focal lengths. The alternative is a zoom lens, whose focal length can be varied with a twist of a ring around the barrel or by push-pulling the focusing control along the length of the lens. Zoom lenses are particularly useful for people pictures, since they allow you to frame your subject accurately in the viewfinder

For head and shoulders portraiture, you need a lens of at least twice the standard focal length. The picture on the left was shot with a 50mm lens which distorts the features; the picture on the right was shot with a 100mm lens.

without having to change camera position too much. One of the most useful zooms for a 35mm photographer is the 28–85mm, giving a wide-angle lens at one end of its scale should it be needed, a good standard focal length in the middle and, at the tele end, not a bad portrait lens. From there, a second zoom of around 80–200mm or 75–210mm adds versatility to a small outfit. In fact, it would be quite possible for the freelance, concentrating on people pictures, to cover ninety-nine per cent of his or her assignments with no more than these two lenses.

Film

The basic types, naturally, are mono and colour. The mono type can be broken down into traditional silver-based emulsions and the newer chromogenic emulsions; the colour types can be broken down into negative or transparency.

The black and white photographer will probably find most of his needs taken care of with a good average-speed film such as Ilford FP4, rated at 125ASA. It gives a good range of tones, is fast enough to be used in the majority of lighting conditions and slow enough to give a more-than-acceptable grain structure. If your work demands that you move into low-light conditions and/or the use of long lenses with small apertures, needing higher shutter speeds for hand-holding, then you can move up to a faster film such as Ilford HP5 or Kodak Tri-X, both rated at 400 ASA. Again, the range of tones is good, but grain begins to become apparent, especially when the format is 35mm.

The chromogenic films are better suited to the photographer who visualises a lot of low-light work. Ilford XP1 is normally rated at 400 ASA, but can be uprated to 800 and even 1600 ASA. The difference between this and a conventional film is the fact that the grain actually decreases as the speed gets faster. Also it is possible to shoot at different speeds on the same film, have it processed for the highest, and still get perfectly fine prints from the images shot at the slower speeds. Against this convenience you must set the inconvenience of a different type of processing. Chromogenic films are processed in either their own formula chemicals or in the standard Kodak C41 colour negative process and must maintain higher than normal temperatures at the development stage.

The serious freelance photographer will have little use for colour negative film, unless he is specialising in portraits for sale direct to the subjects. The photographer who sees publication as his goal should stick to reversal films, since printers make far better reproductions from transparencies than they do from prints.

There are two types of colour reversal stock: daylight and artificial. Daylight film can be used in normal daylight conditions and also with electronic flash; the most commonly-available

artificial light film is termed Type B and is balanced for tungsten light, should you be using that in a studio set-up.

The colour photographer seeking to get his pictures published must get totally accurate exposures, and so it is worth considering the use of Ektachrome Professional films when you are shooting colour reversal. Unlike the normal Ektachromes, these are available in batches that have been tested and individually assessed for speed. What is usually thought of as a 64 ASA emulsion, for instance, can actually vary between, say, 50 ASA and 80 ASA. Those variations can make a very real difference to exposure for reproduction. The Professional stock has its *actual* speed on a leaflet inside the film box and, for best results, that should be noted and adhered to.

When choosing any film, mono or colour, negative or reversal, you should always go for the slowest possible for the job in hand. Excepting chromogenic emulsions, the slower the emulsion the better the grain structure and so the better the quality. Contrast also increases as films get slower, but this is more evident in mono than in colour and can largely be controlled in the processing.

Flashguns

Two very different types of flash are useful for people pictures. The first is the standard flashgun that fits to the camera; the second falls

If you must use a hand flashgun, it is a good idea to get it away from the camera on an extension lead, shooting with the flash at arm's length.

For the freelance on a budget, tungsten lighting can give perfectly saleable results. The hardness or softness of the light varies with the size, shape and texture of the reflector.

into the category of studio flash. A good rule of thumb when buying a flashgun is to simply pay the most that you can afford for the best within your means.

A small, hand gun, made by the manufacturer of your camera will, more often than not these days, be dedicated. This means that when you slip it into the hot-shoe, information is exchanged between the camera and the flashgun automatically. When the flash is charged, the camera's shutter is automatically switched to the correct synch speed. Some combinations take readings from the film plane, or emit an infra-red pre-flash to size up the situation, and then allow you to use any aperture within reason, adjusting the light output according to the subject to give correct exposure.

For taking pictures of people, however, the hot-shoe is probably the worst possible place for the flashgun. At the least, you're better off with a hammer-head gun that can be fitted by a bracket at the camera's side, or, better still, used with an extension cable some

Studio flash units can be adapted in many different ways to vary the quality of their light. Bouncing them into a brolly is a traditional way of producing the softness that is required for most portrait subjects.

distance from the camera itself. So go for a gun that links to your camera's flash socket by cable, not for one that works only from the hot-shoe.

If you think you will be taking a lot of flash pictures, consider too the very real advantages of using Nickel Cadmium batteries rather than the normal Alkaline types. A flashgun runs batteries down very fast and there's nothing more frustrating than waiting an age for the flash to recycle when you are in the middle of a photo session.

If you are planning a lot of studio work, then you need to equip yourself with a few studio flash outfits. These take the form of larger, mains-operated flashguns that fit on lighting stands. They are more powerful than the average hand gun and they recycle far faster. The basic unit takes the form of a flashtube in a small reflector, but they can be adapted to give several different forms of lighting, according to accessories that are fitted to the front.

Using the flash through a honeycomb – a criss-cross foil – softens the light; fitting a snoot, concentrates it into a small, hard spot. Large diffusers, made of thin white material can be fitted in front of the flash to soften the light, or the flash itself can be pointed away from the subject and fired into a brolly. That's a specially-made umbrella that, when white, gives a wide, soft light similar to that obtained by the diffuser. Using a silver brolly hardens the light, while a gold one warms the model's skin tones, and is particularly useful for glamour work.

Filters

There are three types of filter: contrast filters for black and white

photography, colour correction for colour photography and optical devices that give various special effects.

The most commonly-used colours in the first type are yellow, green, orange, red and blue. Filters, used with mono, are designed to lighten their own colour and darken their complementary. Those that will be used most when photographing people are green and blue. A green filter, used with a pale-skinned girl will darken her complexion and lips; blue is useful in male portraiture, lightening blue eyes and darkening complexions even more.

The most useful colour correction filters for this subject are an 80A for using daylight colour film in tungsten light, an 85B for using tungsten-balanced film in daylight and either 81A or 81B,

Filters have a limited use in people pictures, but a green one is useful for darkening the complexion of a pale-skinned model.

both of which are straw-coloured and are useful for warming pale skin tones. The 81B is the stronger of the two.

The optical devices which have become known as special effect filters are a law unto themselves. There are many different types, giving effects that range from starbursts on highlights to multiple images on your principal subject. They make interesting pictures but, except for certain specialist markets, such as the photo press, they have little to do with the success of saleable people pictures.

Other accessories

There's a common belief that tripods are old-fashioned and of little use to the modern photographer. Don't believe it. A tripod is very useful, especially in the studio. If you're going to buy one, buy a firm one. Anything less than rock-steady will defeat its own object. And while you're at it, add a cable release to make doubly-certain of curing camera shake.

Most modern cameras have built-in meters, but don't let this put you off the idea of a good hand meter. With a hand meter, you can take a reading close up to your subject without moving the camera, and you can use them for incident-light readings particularly useful in colour. In the studio, you will find a flash meter invaluable. This is a special type of meter that is geared to taking readings from the brief light of a flashgun. Using multiple flash set-ups, it's the only safe way of ensuring correct exposure.

Motor drives and power winds are far from essential for this type of photography, but they are useful, allowing you to keep shooting

For a professional background, rolls of seamless paper, hung from purpose-built stands, give the best result.

without the necessity of moving the camera from your eye. If you aim to invest in one, you'll find little need for an actual motor drive, unless your particular branch of people photography concerns sport. In general, it's better to invest in a less-expensive power wind.

Studios

Studios can be permanent or mobile. If you think you'll need a studio only occasionally, it is worth hiring one. Addresses of those nearest to you can be found in the local Yellow Pages or in the classified advertisements at the back of most photographic magazines.

If you want one of your own, you'll need a room of at least 15 feet in length, because that's the minimum in which you can comfortably take full-length portraits with a standard lens or head-and-shoulders shots with a medium-tele, while keeping a decent distance from your background. Walls are best painted black to prevent unwanted reflections from lights; windows can be fitted with blinds to keep out daylight when you are shooting with artificial light or for removal when you want to shoot by natural light.

The average domestic garage is an ideal size and shape in which to build a home studio. If you need a less-permanent affair, you can transform the average-sized room providing its walls aren't painted a strong colour that might shed a cast on the model's face. Also it's a good idea to remove pictures and mirrors from the wall to prevent unwanted reflections and to hang heavy-duty curtains at the windows.

For best backgrounds, you should use coloured paper, obtainable from professional photo suppliers in rolls. There are a variety of ways in which it can be held in place behind your model.

Lighting is best supplied by the studio flash units already mentioned, but the photographer on a budget can get similar results with tungsten lighting, available in different sized reflectors for hard or soft light effects. A small, deep and highly-polished reflector gives a hard light; a large, shallow, matt reflector gives a soft light.

A mobile studio is useful for the photographer wishing to sell pictures to people privately in their own homes. Equipment for this purpose should be kept as simple as possible. Small studio flash outfits make the most convenient type of lighting. Two heads with brollies and perhaps a diffuser are the very most you'll need; one head with a brolly, used with imagination, can produce perfectly acceptable results when necessary.

Working in the confines of some else's house, you'll rarely find a suitable background and so a portable one is a must. Two simple possibilities are a folding projection screen and a piece of felt that can be rolled for transport and which will hang naturally without creases when pinned to a wall. Always keep in mind the way the simplest of equipment can give top results.

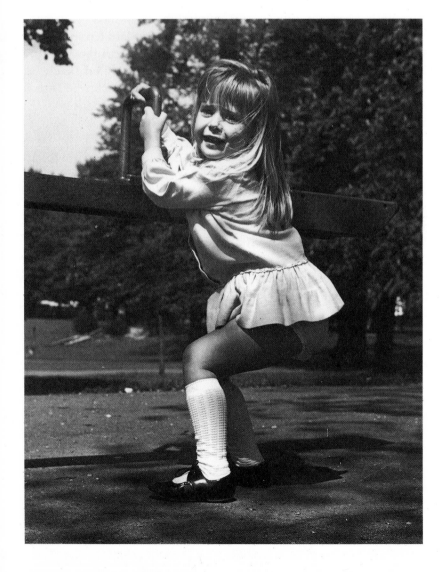

Children are people too and can be excellent sellers to magazines that range from the women's to the photo press.

People and Poses

What sort of people make suitable subjects for saleable pictures? Quite simply, *every* sort: from babies to pensioners, from pretty girls to ugly men. There's a market for them all if they are handled in the right way. Which is what we're looking at in this chapter. We're going to consider first the different types of people available to your camera, then how best to pose and photograph them for profit.

Pretty Girls

Make no mistake about it, pretty girls help your pictures sell. However sexist it might seem, the facts are there for all to see: girls on the covers of magazines, girls on advertisements, girls on Page 3 of *The Sun*. Look in on the news desk of any local newspaper and see how they use pretty girls. The picture of the mayor opening the new shopping centre will be relegated to an inside page, but a picture of a pretty girl, doing nothing more than basking in a sudden burst of hot weather, will make it to the front page everytime. Feminists might fight it, but it's a fact of life. Pretty girls sell pictures. Get them into yours and you will increase your sales potential.

Pretty girls can help you sell several different types of picture. Perhaps a girl is involved in some form of general activity that doesn't actually concern her personally – a canoe race down the local river, a sponsored walk, that sort of thing. Or perhaps she is the only girl in an all-man club or other activity. Faced with a situation like that, you have a ready-made sale for the local newspaper, and when you come to shoot it, make sure the girl is used as the focal point. Get her surrounded by the men, ask them to hoist her on their shoulders, make her the subject of the picture. If she is just one person in an event entered by many, single her out. Go for the prettiest girl in the crowd and you'll be on your way to more picture sales.

Taking that idea one step further, perhaps the girl herself *is* the main point of interest – the girl who wins through to the local carnival queen finals, for instance. Again, if you were attempting to sell to your local newspaper and you had a choice between covering the carnival queen contest and a presentation at the cricket club, it wouldn't take a genius to see which had the better sales potential. With a picture like that, the girl would need to be strong in the

Girls are more newsworthy than men. Find a reason to get a girl or a group of girls in your pictures and it will help them to sell to markets like local newspapers.

frame – a close-up of her with her crown on her head and laughing perhaps, or a full-length shot of her jumping for joy at the end of the contest – in short, a pose that makes it plain that she, and she alone, is the point of the picture.

But perhaps the biggest, and most popular, reason for shooting pictures of pretty girls is for their own sakes, as potential pictures for magazine covers, calendars, even record sleeves or greetings cards. If you have that in mind, the first rule to learn is a cruel one, but it's a rule that must be obeyed if you are out to sell. The fact is that once a girl has passed twenty-five, her sales potential drops like a stone. If you don't believe that, just take a look at the pictures on the front covers of national magazines in your local newsagents. Talk to any professional model these days and she'll tell you that she started working at around seventeen years old and fully expects to be looking round for a different line of work by the time she is twenty-four or twenty-five. The same is naturally true of amateur models. The hard fact is that if you want to compete and sell to markets like magazine covers, you won't do it by photographing your thirty-plus-year-old wife. If she's the understanding sort, go

for the girl next door or a professional model. If that puts marital harmony at risk, take up landscape photography.

Two types of model are open to you, amateur and professional. Both have their advantages and their disadvantages. The amateur model's biggest advantage is that she will settle for a moderate fee or maybe a set of pictures. Her disadvantage is a lack of experience that can lead to stiff poses and unnatural expressions, until she gains confidence and learns how to relax in front of the camera. Look for a girl with good features and a lively personality. A girl who is beautiful in the traditional sense won't necessarily be as good a model as one who is perhaps a little plainer but has the personality to come up with the right kind of expression and pose. Certain features are more important than others, so look for a girl with beautiful eyes and, if possible, with fine cheekbones. Watch

Glamour models are people too—and there is a big market for glamour pictures from magazines and newspapers, through to advertising and calendars.

the way she smiles: that can make all the difference to a picture's sales potential. One good place to look for amateur models is in your local drama group. The extrovert nature of an amateur actress will be a strong point in her favour as a model. Also, as an actress, she will know a little about using expressions to convey different moods.

Approaching a complete stranger and asking her to model for you can be a tricky business. If you don't want her to get the wrong idea, you must adopt a confident and professional approach. Have some pictures of past work printed ready to show her, give her a business card or, at the very least, your phone number on a piece of paper and ask her to think the matter over before she calls you. Little things like that will usually convince her of your integrity as a photographer.

You will, of course, have no such difficulties with a professional model. Also, she has the advantage of having the right face and figure for the job, and she'll know how to use them in the most photogenic way. The disadvantage is that she can come expensive, although when you weigh her fee against the fact that she will probably lead you to many more picture sales, she makes a good investment. Many of the studios that you'll find advertised in the classified section of the photographic press have their own models on the books, some of whom are full-time, others who are only part-time professionals. Any reputable studio will have lists with pictures for you to choose from, and you can book the model when you book the studio.

All the top professional models have agents, most of whom are based in London. Directories are available that list the agents and the models on their books, or you can find them in the London telephone directories. Every agent will have an index card for each model, showing their pictures, listing their statistics, colour of hair and eyes, height, etc. together with the type of work they undertake. If you want to book one of these models then, in the first instance, you should telephone for an appointment and visit the agency personally the first time to convince them of your integrity. They will then help you find the right model for the pictures you have in mind. Never forget, however, that, in this field, you are dealing with the real professionals and they come very expensive, charging not only for the time taken during the photo session, but also for travelling time as well. You really should be sure of your market before you approach one of these agencies.

Glamour models

Glamour photography is one step away from the photography of pretty girls. There is a tremendous market for the subject when it is

well done, but that's the point: it must be well done. There is very little worse in photography than bad glamour. It really goes without saying that the girl chosen as a model must be young and pretty, but she must also have a good figure and not be embarrassed about displaying it in front of the camera. This is one place where a professional model really is a necessity. Amateur models *can* be used for glamour photography, but it's a rare one that leads the photographer to really top sales. Models, then, should be booked through their agents, as detailed above and, when making your choice, you should examine their index cards very carefully. Some girls, even though they are professional models, won't pose for glamour pictures at all. Others are available for topless work, but not fully nude. Make sure you book the right girl for the job in hand.

Model Index Cards help you find the right model for the type of pictures you have in mind.

Children

Second only to girls, children can bring you a lot of picture sales, from magazine and book illustrations to greetings cards and photo contests. They can make excellent models, but they need to be treated with care and understanding.

Children are naturals. Even when they are posing, they can look natural. Guide them towards the kind of pose you want, but allow them to interpret your instructions in their own way.

Good looks are not a necessity. Character and personality are far more important. If the child enjoys being photographed, he or she will respond to direction for a while, but will soon become tired. When that point comes, you must recognise it and stop shooting for a while. Character and personality traits develop very early, almost from the time a child learns to sit up. By the time they are around three years old, they will begin to understand what the camera is all about and will usually enjoy posing for it.

Other models

Girls and children aren't, of course, the only people around. Men make models too, as do middle-aged people and pensioners, all of whom can make excellent subjects for the camera. Good subjects, certainly; but not necessarily *saleable* subjects. You'll find very few publishing outlets for pictures of men or middle-to-old age people, in the way you'll find markets for girls or children. The exception is the character study of an old man or woman that might stand you in good stead in a photo contest, or a picture of a man involved in some work or hobby that is the principal point of the picture.

While publication of some sort is a major force in selling pictures, it is by no means the only outlet for picture sales, however. Commercial portraiture, either in the subject's home or in your own private studio can contribute a major slice to your income and, with that, you can find yourself being asked to photograph anyone and everyone, of either sex and at any age. The difference between this type of photography and that designed for publication, is that you, as a photographer, won't be looking for a specific type of model for your own purposes. Rather, your models will be coming to you in all shapes, ages and sizes and demanding that you make them look as good as possible in front of the camera. The technique here, then, is not in finding the right model for the job, but in making the most of what's in front of you. It's all down to the basics of posing, and that's where we're going next.

General posing

Unless he or she is a professional, one of the biggest problems your model has to face is learning how to relax in front of the camera. Little things that we all do naturally, like smiling or flashing our eyes, or even just the way we sit, are all difficult to do to order. The minute your model's attention is drawn to a certain action or expression, he or she will inevitably become self-conscious. It's up to you to iron out these problems, to help your model relax and, strange as it might at first seem, to show them how to do it.

When it comes to the photo press, people can be used in your pictures to illustrate techniques or the way equipment works. These three pictures show perspective changes with different lenses.

Smiling is one of the most natural acts around, but ask someone to do it for the camera, and you could find yourself faced with a very stiff and awkward pose. What many people fail to realise is that a smile does not concern itself uniquely with the mouth. A smile lights the eyes as well. So the person who, told to smile, merely turns up the corners of their mouth without bringing the necessary light to their eyes will look grim and menacing instead of carefree and happy. So eyes and mouths are your biggest problem. One way out of the problem is to actually remind your model how he or she naturally smiles. Chat for a while, crack a few jokes; when your model laughs, point out *how* he or she is laughing. Let them see what is happening to their own features, then ask them to try repeating it. Tension is one of the big problems. It tightens face muscles, especially around the mouth. Talking and laughing relaxes the muscles. Similarly giving your subject something to do helps relaxation: filling the mouth with air and blowing it out or just the act of licking the lips, both help the muscles 'forget' their tension.

The biggest problem with eyes is the way they tend to go dead while the subject is waiting for you to take the picture. Again, it helps if you can give your subject something to do in an attempt to make them forget their nerves or tenseness. If you notice eyes taking on the blank, glassy look that is so common in amateur portraiture, try this. Ask your models to look right away from the camera, at their feet, a nearby wall or the ceiling maybe. Then, when you're ready to take the picture, tell them to turn back towards the camera, smiling at the same time, then take the picture with the action. The effect will be a far more natural expression. Another way to get a similar result is to ask your models to close their eyes, then to open them wide at the moment of exposure.

While you are posing your subject, it is up to you to keep him or her as relaxed as possible, so talk all the while you are working, explain what you are doing and mention how things are looking through the viewfinder. Be encouraging and say when things are looking good. Say they're good, even when they're not. The worst thing you can do is to bury your head in the viewfinder and just wait for the model to do something. Keep directing, keep talking and you'll end up with natural expressions.

Formal poses

The head-and-shoulders shot can be very commercial, both with private portraiture for sale to the subject and for publication. It is rarely a good idea to ask your model to face square-on to the camera. It's better to start three-quarters-on, then to turn the head back so that it is at an angle to the body. With the head straight, the pose will look formal and fairly serious. Ask your subject to lean forward so that the body and head are more at a diagonal in the picture area and the pose will immediately look more relaxed. If the head is tilted back, in relation to the body, a certain amount of vitality will be conveyed, but be careful not to take this idea too far, or your model will become uncomfortable and the pose will start to look unnatural.

When the subject is full-faced to the camera, eye contact with the viewer is inevitable and a feeling of intimacy is built up. As such, it's the pose that is used most for magazine covers. With a girl as model, asking her to look down and then to flick her eyes up at the camera will give her a wide-eyed, innocent look. As such, the pose is not suitable to male portraiture.

With the model's face three-quarters to the camera, but with the eyes towards the lens, a nice, relaxed look is produced, but keeping the eyes straight ahead, and so obliquely away from the camera, will make the model look more pensive. It makes a good pose for commercial portraiture, but it's an unwise one if you are seeking publication. Much the same is true of the profile shot. Unless it is being used for a specific or dramatic effect, profiles won't sell to magazine covers and the like. Because the pose also makes the subject look aloof, it isn't very popular with the subject either and so won't sell too easily as a commercial proposition.

Much of what has been said above applies equally to three-quarter and full-length poses. It is rarely wise to photograph your subjects full-on to the camera, but better to ask them to turn in profile, then to swivel their hips back a little way and to turn their eyes to the lens. If legs are to be shown in full, don't allow your model to keep them stiffly together and straight. A better pose results from your subject taking weight on one leg and bending the other one slightly.

Don't shoot people candidly from a distance. If you want to make sales, move in close and involve yourself with the subject.

Once you get away from head and shoulders work, you also have the problem of what to do about arms and hands. Most of all, they must be kept relaxed, along the back or the arms of a chair maybe; or given something to hold. Never truncate your subject at the wrist and never have part of an arm coming in from the side of the picture as though it belongs to someone else. Always show a hint of the obvious: that arms are joined to the body of their owner.

Informal poses

Very often pictures of people designed for publication are not really about the people themselves, but more about their concern with a sport or pastime. This is where informal posing comes in. There is a good market amongst hobby magazines for people working at crafts: potters, weavers, carvers, painters and the like. In photographing subjects such as this, you must adopt a style that is half way between formal posing and candid photography. Ask your subject to work normally and watch what he does. Decide for yourself which is the most photogenic aspect of the actions he is performing. Then ask him to start all over again and take your pictures. He might be a little self-conscious at first, but you must be unobtrusive and allow him to work naturally. He'll soon become absorbed in his work and you'll find you are getting some very

saleable pictures. Remember that this market will want to see, not just the weaver or whatever, but also what he is doing, so take general shots of the action, then move in close to show the weaver's hands on the loom, the potter's technique at the wheel, etc. Go for facial expressions too. When a craftsman is wrapped up in his work, you can get some lovely character studies that could find other markets such as photo contests or might perhaps form the basis for a feature in the photographic press.

Glamour poses

Many of the basics of glamour posing are similar to details covered in formal posing. The first thing to remember is that we really are talking about *glamour* and nothing else. It's up to you to portray your model in the best light. The dividing line between glamour and bad taste can be a thin one and you should always be aware of that fact. It isn't enough for the model to merely show off her body, she must do so in an attractive way.

Good glamour photography usually has an element of the erotic about it, but eroticism can be fun or it can be sordid. Your pictures should come down heavily on the former. Remember that a partially-clothed body is always more erotic than a fully naked one and so use costumes to their best effect. Certain materials like lace, satin or silk are more glamorous than others, so use these or similar whenever possible. A good glamour photograph is one in which the model looks beautiful, both facially and in her figure, happy, but – most of all – *attainable*. That's what you're selling when you sell glamour. Remember that and you'll make more sales.

Little details can make all the difference. If you're working in a studio, background music can help relax both the photographer and the model. It sounds obvious, but don't forget that she is undressed: make sure she's warm enough.

Legs make a good starting point for a pose. Take notice of what was said before about posing in general. Don't shoot them full-on. Turn your model in profile or three-quarters to the camera, ask her to take the weight on one leg, to bend the other. There's no need to show all your subject's legs. A lot of glamour poses are cropped at the thigh. If you are showing her full-length, then don't let her stand flat-footed. Always ask her to move up onto her toes as you take the picture. Alternatively, high-heeled shoes – a traditional glamour prop – will do the job for you.

Moving up her body, watch the way she holds her stomach. Keep it flat by asking her to breathe in as you take the picture. If she has a small bust, it can be accentuated by asking her to lean forward and pulling her arms close in to her sides. Leaning back will make a large bust look smaller. Raising her arms above her head makes a

Always carry your camera, you never know when you might meet someone like this. The picture has sold over and over to markets that ranged from the local newspaper to a supermarket house magazine.

When posing your model, try to get a natural, relaxed expression, rather than a tense one that is guaranteed to put editors and picture buyers off your work.

too-large bust more attractive. Pulling back her shoulders will give her a better shape and, once again, her bust will look better three-quarters to the camera than straight on.

When it comes to the face, remember that she must look natural. A nervous or tense glamour model makes very bad pictures. So remember what was said earlier about getting relaxed expressions. Those basics apply all the way down the line, whether you are photographing a fully-dressed, fifty-year-old spinster or a half-naked teenager.

Posing children

Children can be posed in several ways: formally, much in the way you might similarly pose an adult, or in a natural environment such as a playground or park, when they are involved with their own activities and you can capture them candidly. Children will also pose in a way that adults never would. They will perform for you.

The straight-on pose rarely works. It's better to turn your model three-quarters to the camera in head and shoulders work.

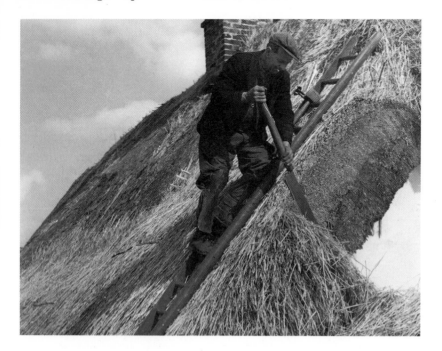

When you are photographing someone involved in a craft or hobby, make sure you pose them rather than shooting candidly. Your reader needs to see exactly what's going on.

Give them a prop to play with – an old hat, a pair of sunglasses – or put them on a climbing frame maybe and, until they grow bored, they will come up with pose after pose without you needing to do any more than press the shutter.

In more general play, you'll find that children have a wonderful concentration for what they are doing. After a few minutes of showing-off for the camera, they will become absorbed in some game or activity and completely forget you are even around, leaving you free to shoot picture after picture without any of the embarrassment that you might find in adults in similar circumstances.

If you are taking children into a studio, pause for a moment to consider how all the lights and camera apparatus might look to them. From their viewpoint, it can look a little scary, so take time to explain what everything does and what you are going to do.

Never photograph a child when he or she is tired or hungry, and remember that if you are working formally, what starts as a game will rapidly turn into boredom for them. Once you see that boredom setting in, think of a completely different pose or stop altogether. Make a game of it, keep the child interested and you'll get some great pictures. But never try to push children past their threshold of boredom.

Disguising defects

Nobody's perfect! But to sell people pictures, you have to make

your subjects look as perfect as is humanly possible, both for publication sales and especially when you are selling your pictures to the subject themselves. You'll never make an ugly person look beautiful, but there are a few dodges that will help you disguise certain small defects.

Noses can be a problem. If your subject's is slightly twisted, don't shoot head-on. If it is large, don't shoot in profile. Long lenses can be used to slightly flatten perspective and so apparently shorten long noses to a degree. Baldness can be hidden by shooting from an angle below the cheek line and, conversely, shooting from above this area will help to hide double chins. Subjects with large ears should be photographed in profile or three-quarters to the camera, never full-on.

Lined faces can make wonderful character studies, but in some models – middle-aged ladies, for instance – they are undesirable. Lines can be ironed out by keeping lighting predominently from the front and so flattening its effect, or soft focus techniques can be used. Special lenses and filters are made for the job, but you can create your own soft focus by diffusing the image with a piece of black nylon stretched over the lens and held in place with a rubber band. Other soft focus methods of which you might have heard – smearing Vaseline on a filter, shooting through Cellophane or strips of Sellotape – take the effect too far, away from the subtle effect you need and more into the realms of special effects.

Blotchy skins or freckles can be taken care of in black and white photography, by the use of a filter. In mono, filters lighten their own colour, so a pale straw colour such as an 81B or, more drastically, orange, will make a freckly face look plain. By the same token, however, it will also reduce the tone of lips and so, with girls at least, you should ask them to wear darker than normal lipstick when shooting this way. In colour photography, the 81B filter can be used to give a more sunbronzed look to pale skin, and a similar effect can be had in black and white by the use of a green filter, remembering that this will also darken red lips. A shade *lighter* lipstick would be advisable in these circumstances.

If a person is short, shooting from a low angle will make them look taller; high angles will make tall people look shorter. If a face is a little fat, side lighting will help to make it appear slimmer. More frontal lighting will have the reverse effect on thin faces.

Spectacle wearers can present problems. If your subject wears them, make sure you can always see his or her eyes behind the lenses and take care with reflections from studio lights. A slight change in camera position, up or down, will usually solve the problem.

Using the Light

Until you really start to take notice of light, you don't realize just how much it varies. Light varies in intensity, contrast and direction, and each variation has a different effect on your subject.

Hard versus soft

When light comes from a small, bright source, it's hard; when it comes from a larger, duller source, it's soft. In the studio, hard light comes from tungsten lamps or, more often, flash units, reflected from deep, highly-polished reflectors. Outdoors, the same effect comes from the direct rays of the sun. Back in the studio, shining light through a large diffuser or reflecting it from a white umbrella softens the light; outdoors, a similar effect happens when the sun is diffused by light cloud.

In general, it is rarely flattering to photograph people in hard light. There are, of course, exceptions. In a character study, the lines on an old man's face will be accentuated by hard light. But in general, soft light makes far more pleasing – and far more saleable – pictures.

In the studio, then, people are mostly photographed by diffused or reflected light, combined in ways that we shall be coming to later in this chapter. Outside, you have less control over the lighting and must adapt to what is there. The direct rays of a bright sun are far too hard and so on days when there is no cloud, you are best shooting in open shade. Conditions are better when the sun is diffused by a light cloud to soften the shadows. What this softening process is actually doing is reducing the contrast of the overall lighting and so, the more cloud there is about, the more contrast drops until, when the sky is totally overcast, the light is at its softest and the contrast at its lowest. Such conditions are equally unsuitable because now there is not enough contrast in the lighting on your subject and its surroundings.

Depending on the reflector or diffusers in use, light can be hard or soft. Each has its own effect on a face, hard light giving harsh shadows, soft light reducing them.

Direction of light

The direction from which light falls on your subject also has its effect. In the studio, light direction is altered by the simple expedient of shifting lighting stands. Outdoors, direction depends

on the time of day and the position of your subject relative to the sun. The effects produced, however, are largely the same.

Front lighting is flat and dull. It destroys the modelling in your subject's face and makes the face look fatter than normal. Outside, if the light is coming from the sun, it will make your subject squint. Overall, it's a bad light to use for people pictures.

Move the light (or your subject in relation to the light) more to one side and modelling immediately improves. The shape of the face begins to look more normal and texture in the skin becomes more apparent. Lighting from around 45 degrees, especially, coming from higher than head-height to the subject, gives the best rendition of a face, but used alone it also casts nasty shadows. We'll be dealing with ways to get rid of those later.

With the light coming at 90 degrees to one side of your model, the face is divided in half, one side brightly lit with little or no texture, the other in shadow. One eye will disappear into the shadow and even the one on the bright side of the face will be heavily shadowed by its own socket.

Moving the light round to an angle behind the subject gives you, at around 45 degrees, what is known as Rembrandt lighting, named after the painter who so liked to work with this type of light from a window. The face is still divided heavily into areas of light and shade, but now there is more texture in the lit side. There is no light to be seen in either eye.

With light directly behind the subject, the face is thrown into deep shadow and a bright rim of light is traced around the outline of the subject's head and hairline.

When light comes from directly overhead, the top of the head is

illuminated, giving texture to the hair, but the face suffers as eyes fall into deep pools of shadow.

These examples take light direction to extremes. They are the effect of one light on a person's face with no other help to aid modelling. The effects described are merely the principal effects resulting from the different directions of a single light, but indoors or outdoors, they form the basis of the final effect. In the studio, other lights will be added to countermand the deficiencies of the single light; outdoors, trees, buildings, the ground, even the sky itself all provide reflectors that bounce light around and fill the shadow areas. In order to shoot your subject in the best light, you need to know how to use and combine these effects in the right combinations.

Studio lighting

There is one, basic, lighting set-up that has been used by studio photographers practically from the first days of studio lighting. A version of it worked in the old days with tungsten and it works just as well today with studio flash. It consists of three lights and it is suitable for just about ninety per cent of the pictures you are likely to take for sale. Here it is, broken down into three, simple steps.

1. The main light, softened by reflection from a white brolly, is

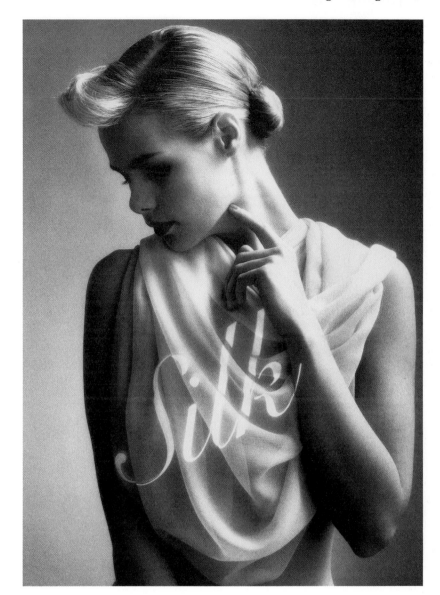

The direction of light is also important. Depending on how it strikes a face, it can reveal or reduce texture in the skin surface, add highlights to the hair, even make a face look fatter or thinner.

set up at between 30 and 45 degrees to your subject and above head-height. It is placed on the side to which your subject will be principally facing. This is the light that gives your subject's face its correct modelling and, before any other lights are added, this is the light from which you take your exposure.

2. The fill-in light, also bounced from a brolly or shone through a diffuser, is placed on the other side of the camera. This is used to fill the shadows cast by the first light. It is not there to *eliminate* the shadows, otherwise modelling in the face will be lost, only to bring some light to them and take away their harshness. The strength of this light should be about half that of the main light. That can be adjusted by means of a control on the back of most studio flash

A standard three-light studio set-up will see you through the majority of portrait-type subjects that make sales.

outfits, or ascertained by the use of a flash meter, measuring the output of each light separately.

3. The effect light is hard and usually shone through a snoot. It is used from directly above the model to light the crown of the head, bring life to the hair and to help separate the model from the background.

That's your basic set-up and will give you lighting that's perfectly adequate for most saleable pictures. There are, however, a couple of additions that will enhance the lighting even more. A fourth light can be used exclusively for the background. Shone from one side, or preferably, from behind the model, out of camera range, it can be used to kill any unwanted shadows or, with the

addition of a suitable gel, to colour the background, either overall or selectively. A light placed on the floor and directed up at the background will give a graduated effect, light at the base of the picture, gradually darkening towards the top.

The other addition might be a reflector, used on a head and shoulders girl shot, below the model's chin, out of camera range, to throw some light back into her features and help lighten shadows that can be caused on her forehead by her hairstyle.

A slightly different result can be had by moving the effect light from overhead to directly behind your model, so that her head is blocking it from the camera. The light will then throw a strong halo of light around her hair, separating it dramatically from the background. Coloured gels can be used to give the halo different colours and, because the effect works best against black, there is no need for a fourth background light.

If you don't have the resources to equip or hire a studio with lighting like this, you can cut down to a minimum of two lights, using the main one closer to the camera so that it doesn't throw such strong shadows, then filling what shadows there are with a large white reflector opposite the light and as close to the model as possible without intrusion into the picture area. The second light can still be used as an effect light on the hair.

For male portraits, there is a completely different three-light set-up that is very effective, but because of its hardness it is unsuitable for pictures of girls or women. In this, two lights are placed behind the model, each at around 45 degrees to his head and a third, half the intensity of the other two, is placed close to, and just above, the camera. The result is a face partly in shadow with a bright highlight to each side, plus a hairline and collar that is sharply defined against the background.

There are of course many, many more lighting set-ups, but unless you are actually out to sell pictures specifically designed to demonstrate lighting to markets like the photographic press, there is little point in going further at this time. If it's publication you're after, you'll need little more than a well-lit, well-defined figure or face and the first, basic set-up with the two variations detailed above will give you most of what you need.

Light outdoors

Just as in the studio, outdoor shooting works well when the main light is between 30 and 45 degrees to the subject. In this case, the main light, of course, is the sun. That means that the best time to shoot is when the sun is fairly low in the sky. Early morning and late afternoon are both ideal, but not *too* early or *too* late because then the sun tends towards red, giving your subjects unnatural skin tones, both in colour and in black and white.

Whether it's from a studio light indoors or the sun outdoors, backlighting will always produce a halo around the subject's hair.

Shooting at mid-day when the sun is directly overhead is largely impractical, suitable only for pictures in which the model is lying on the ground: certain types of glamour work, for instance, in which the girl might be sunbathing. If you are forced to shoot in these conditions, then move into the shade of a tree, use its leaves to soften the light and fill in the shadows with a reflector or small hand flash-gun. (We'll be coming to details of how to do that in a moment.)

Reflectors, in fact, are your strongest ally when shooting outdoors. You can use the large, professional units that stretch fabrics across a specially-made frame, or you can make your own. First and foremost, they need to be large. Around 6ft. square is a

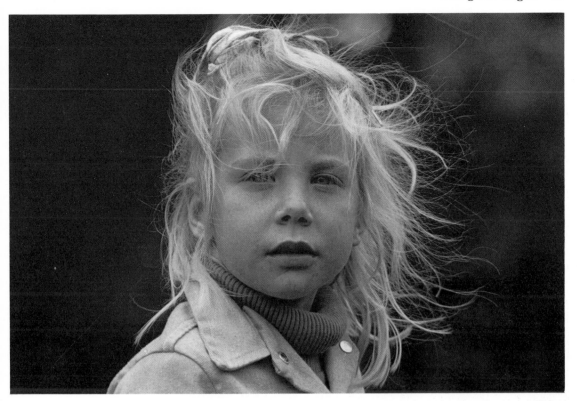

useful minimum. They can be made from any suitable white material, such as a table-cloth or bedsheet, hardboard painted with white emulsion, or sheets of polystyrene. The lightness of the latter makes it very attractive, but because it is brittle and blows about in even the slightest breeze, it can be a little impractical in the open air.

The colour of a reflector has its effect outdoors, as much as it does when used with studio lights indoors. A white reflector gives a large, soft light that fills shadows with a perfectly natural look; a silver reflector fills the shadows with a harder light; a gold one provides a warm fill that gives your model lovely tanned skin tones. The gold reflector is very useful in glamour photography.

Reflectors are also useful in the open when photographing your subject against the light. The use of back lighting in people pictures is one of the most useful techniques you can learn, and it's so simple. It is particularly effective when your subject is female. Posing your model facing the sun has two major disadvantages: the lighting itself is flat and its brightness will usually make her squint. Turn her round, with her back to the sun and immediately a beautiful halo of light is traced around her hair, as well as the textured edges of her clothing. But because the main strength of the light is now falling from behind your model, her face is in shadow.

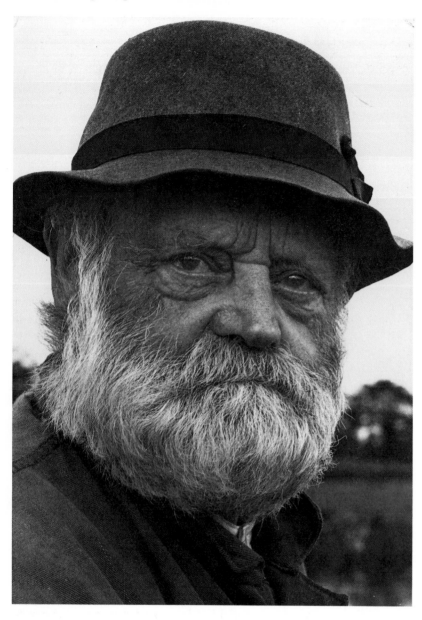

Outdoors, you have no real control over lighting the way you have in a studio. You have to use, and adapt, what's available.

That's where the reflector comes in. Use it as close to the model as possible and it will bounce some of the back-light into her features, giving a lovely soft light that contrasts so well with the brilliance of that halo around her hair. The trick works particularly well when she is posed against a dark, out-of-focus background.

When you come to make the exposure for a shot like this, you must take care with your metering. The normal TTL metering in a camera will be fooled by the lighting from the rear and, if it is extra-strong, pressing a backlight button won't even be enough to

compensate. You must take a reading from the subject's face, either with a hand meter, or with the camera itself, then move back and set that reading manually. If your camera is totally automatic, you must find another way to achieve the reading, either by operating an exposure compensation dial, or by manipulating the film speed scale. Each time you halve the speed, the system will give you one extra stop. For example, going from 100 ASA to 50 ASA will give one stop extra exposure; changing to 25 ASA will give two stops, etc.

Using flash

Most of today's camera manufacturers make a big thing about their dedicated flashguns. Just slip one into the hot-shoe, you're told, and your troubles are over. The flashgun will automatically set the camera's shutter at the correct synch speed, exposures will be worked out, apertures set, flash adjusted until the exposure is dead right. That's fine in theory, but in practice – and *particularly* when you are photographing people – the worse place you can fit a flashgun is on the camera.

Because the lighting is dead-centre from the front, it is far too flat for effective modelling; because the light comes from a small area, it is far too hard. What's more, it inevitably leads to red-eye, the result of the flash hitting the red of the retina at the back of the subject's eyes and being reflected back into the camera lens.

One way around the problems is to bounce the flash, tilting the head towards the ceiling or a nearby wall between yourself and the model. Providing your flashgun has bounce capabilities and the sensor on the front remains pointing towards the subject, the automation will still work. A better way still is to remove the flashgun completely from the camera and use it, attached to an extension cable, at angle to the subject or bounced into a reflector. This way, using a normal, hand flashgun, bounced into a white umbrella, quite professional results can be obtained. The disadvantage, however, is that you must use the gun on manual and calculate exposure separately, either with a flash meter or by use of the guide number. For that, the total distance between flash and model (flash-to-reflector *plus* reflector-to-subject) is divided into the guide number to give an aperture, which must then be opened up by one or two stops to allow for light absorption from the reflector. A little intelligent trial and error will usually provide details of exactly how much you need to open up for your particular set-up. The second disadvantage of using a small hand flashgun this way is in the long wait for recycling.

It would be all too easy in a book like this to describe dodges that are supposed to get you professional-looking results with the simplest of amateur equipment and, in many cases, they would

work to some extent. But, at the end of the day, we must remember our goal: it's to sell pictures. To do that, you must produce results as good as, and better than, the professionals.

So don't let's kid ourselves. A hand flashgun is adequate for small, not-too-ambitious portraiture in the home. The same flashgun will stand you in pretty good stead, even used on the camera, if you are shooting news pictures for newspapers. But if we're talking about getting the professional results needed for markets such as magazine covers, then you really must resort to professional lighting. It's not unduly expensive. You can pick up a kit with a couple of flash heads, a brolly and diffuser, for little more than the cost of a good SLR. Or you can hire a local studio for quite reasonable rates.

But if you're serious about this market, you won't compete with the professionals with amateur lighting.

Fill-in flash

One place where the small flashgun *is* useful, is for use as a fill-in light outdoors. Use it in place of a reflector, preferably a little way

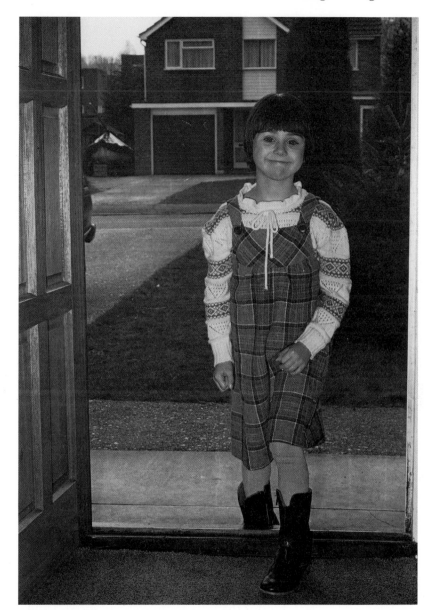

A small hand flashgun can be used on the camera to fill in shadows. Left to right, the pictures were exposed for the background, under-exposing the subject; for the subject, over-exposing the background; and for the background with fill-in flash on the subject.

off the camera, attached by an extension lead, or even, if you have no alternative, in the hot-shoe.

Fill-in flash (or synchro sunlight as it is sometimes called) is a technique that worries a lot of photographers, but really, once you get the hang of it, it is very simple. What you are out to do is add a little artificial light to your subjects, to balance with the natural light around them. The technique also adds an attractive sparkle to your subject's eyes.

The theory is fairly simple. Exposure for flash photography is controlled on the camera only by the aperture. The speed of the flash becomes its own shutter speed. The first task, then, is to find

Even with a small hand flashgun, you can achieve different effects of lighting. From left to right, this subject was lit by direct flash from the camera, bounced flash from the camera, bounced flash plus fill-in from a second tube on the gun, direct flash but with the gun off the camera at 45 degrees to the subject, flash bounced into a white umbrella at 45 degrees to the subject.

the correct aperture for the flash on your subject. With an auto gun, providing you are within the appropriate flash distances (and with a normal picture of a person up to full-length, you inevitably will be), the aperture is dictated for you. On a manual gun, you must find the aperture by dividing the flash-to-subject distance into the guide number for your particular model. Having found the correct aperture for the flash, you then match that with the appropriate shutter speed needed to record the background correctly.

That's the theory. In practice, you can encounter a few problems. The first is unique to owners of single lens reflexes, which of course includes the vast majority of photographers. The focal plane shutter traditionally used in SLRs doesn't usually synchronise above 1/60 second, although a few synchronise at 1/125 second and a very small minority go faster still. If, therefore, the shutter speed dictated by the aperture needed for the flash is faster than the synch speed, you can't easily use fill-in flash.

There are two solutions to the problem. The first is to use a camera without a focal plane shutter. These include some non-reflex cameras, twin lens reflexes and a few rollfilm SLRs, which use between-lens leaf shutters that synchronise at any speed. Failing that, you must position the flash to work with an aperture that, in turn, combines with a practical speed. An example at this point will make things clear.

Let's say you are photographing a pretty girl in the shade of a tree and the metered exposure for the background is 1/250 second at f/8. Assuming your camera won't synchronise with flash above 1/60 second, you must first adjust that to the equivalent 1/60 second at f/16. The flash must then be set to manual, the guide number divided by 16 and the flashgun held at the resulting distance from the subject.

An easier way of going about things is to use a camera that offers

TTL flash metering at the film plane. With one of these systems, you can use any aperture you like within reason (and therefore, it follows the specific shutter speed for flash synch) and, with the flashgun in the camera's hot-shoe, the meter inside the camera will measure the light of the flash at the moment of exposure, take into account the aperture you have chosen, then quench the flash when the film has had enough light.

Another system, used on some other manufacturer's dedicated flashguns, allows you to dial in any chosen aperture, then again the flash's output is measured and quenched at the right moment to give the correct flash exposure. Check your camera's instruction book to ascertain if either of these methods are possible with your equipment.

Working this way, the final picture will show an equal balance of light on both the main subject and the background but, for the most realistic results, it's wise to reduce the light on the subject a little.

Shooting that model in the shade of a tree, for instance, the difference in light on her face and the light on the background might well be too wide for the film's latitude to handle without help from a little fill-in, but the point is that, in the normal way, there will be a difference. To actually balance the two to perfection will only make the picture look false. To make it look more natural, the light on the subject should be slightly under-exposed, by one or two stops, compared to the light on the background. Do that by adjusting the flash's output to that required for a correct exposure at one or two stops less than you are actually using. Alternatively, work out what is correct for a perfect match, then closing down one or two stops, while adjusting the shutter speed accordingly for the background to remain correctly exposed. Once again, remember the problems with synch speeds and work within the restrictions they impose.

Fill-in flash is one of those techniques that always sounds complicated when it is described, but really it's only a matter of good, common sense and, as with so many other techniques in photography, everything becomes clear once you try it for yourself.

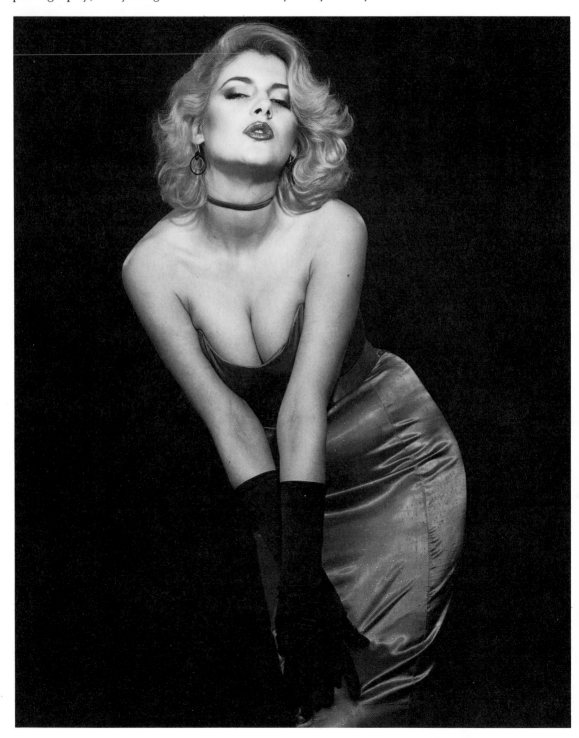

Backgrounds and Props

The subject we're shooting is people. But if the shot is to be successful and saleable, there is a secondary consideration that must be taken strongly into account. We're talking about the background. Backgrounds can be plain or fancy, separate from your subject or a more definite part of the picture and its overall composition. Backgrounds can make or break pictures. Used intelligently, they can enhance the subject; used carelessly, they can ruin a good potential sale.

Studio backgrounds

Working in a studio – either permanent or mobile – a plain background will often be required. It's the sort of backing you'll need for personal portraits for sale to the subject; or for pictures in which the person is the only real reason for the shot: magazine covers are a prime example.

Working with a mobile studio you can improvise backgrounds with the materials we mentioned in the earlier chapter on equipment. Felt is recommended, simply because it hangs well without creases and, if creases do occur, they can be quickly ironed out with a domestic iron. Similarly, a decent sized projection screen will stay in any position you place it and give a good, even tone, again without the problem of creases. If you are lucky enough to find a house with a plain wall of a not too distracting colour, you can use that too for certain types of shot. What you must guard against, when shooting in a private house, is using available backgrounds like wallpaper or curtains. Even the plainest pattern in a wallpaper can make a nasty distraction when thrown out of focus behind the subject; and curtains that look attractive in real life hang in folds that register on film as a series of nasty vertical shadows that will do absolutely nothing for your picture.

By far the best background for a plain effect is seamless paper, sold in the UK under the Colorama brand name. The paper is sold in 9ft rolls and in a range of colours. The size makes it impractical for use in a mobile studio, but rolls can be cut down and, when you're on the move, they can be easily supported by a portable device that consists of a trough for the paper, held above head-height by a special collapsible stand. By far the best method of

If you are shooting for a magazine cover, or for the poor reproduction of a newspaper picture, then a plain background will often be your best way to make sales.

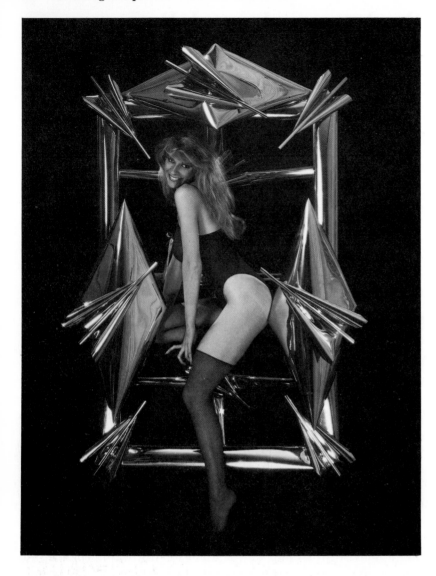

Seamless paper, pulled down from the wall and across the floor in a gentle arc, will give you a plain background for full-length pictures.

using Colorama paper, however, is in its 9ft. width and hung from more specialised equipment. A professional version, fixed permanently in a studio would be geared to allow easy unrolling of the paper. Slightly less professional, but still perfectly adequate for the job, is a lighter framework that consists of two sprung poles, braced between floor and ceiling with the paper slung in a roll between them. While the device is a little too unwieldy to be considered part of a mobile studio for taking into other people's homes, it is perfectly adequate for the amateur or small professional home studio, set up on a semi-permanent basis in a room or garage.

If you are shooting just head and shoulders pictures, then the background paper need not be too large and can be pulled down just behind the model. The same is true for three-quarter length

pictures, but go to full-length and things change. Up to this point, if you didn't have a roll of background paper, the previously-mentioned plain wall would be quite adequate for the job. But shoot full length and you take in a new area. Once your camera gets down to legs and feet, the floor of your room or studio will be evident in the picture and, if you are using an improvised background of any sort, your picture will show an ugly join between it and the wall.

The way the professionals get those lovely smooth backgrounds with no join is to pull the Colorama paper down the wall and out across the floor in a gentle arc. The model then stands on the

Differential focus can be used to avoid messy backgrounds when shooting outdoors.

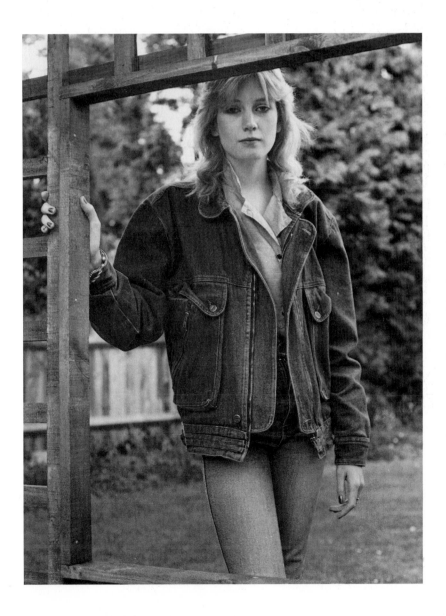

background itself, taking care not to leave any footprints on the paper, something of which the photographer must be equally aware when he is arranging the pose.

If this were a book on general portraiture, we could talk at this point about additional techniques such as throwing shadows on the background to make a more interesting picture. The technique is valid if you are shooting an 'arty' type of picture for sale to the client, but if it's publication you're after, the simplest approach is by far the best. The photographer looking for sales to magazines as covers, should know that editors will want the subject bold in the frame against a plain background on which they can add their logo and coverlines (the words that tell readers what's going on inside the magazine). If its newspaper publication you're after, fuss-free backgrounds are an essential. Reproduction in newspapers is bad at the best of times, and this is no market for subtlety. Again, the subject needs to be bold against a plain background.

The colour of the background is important. If you are shooting for publication in black and white, don't go for grey. Use either white, separately lit to get rid of any shadows from the subject, or black, with backlighting to help lift the subject from the background. If you are shooting commercial portraiture, it will probably be in colour and here you can afford to be a little more creative, blending background colours with the subject's hair colouring, clothes, or just the overall mood of the picture. Shooting colour for publication, you're again best off going for the simple, bold approach, but choose your colours carefully.

Certain colours appear to advance in a picture, while others recede. Taking this to extremes, red is the most dominant colour of all and will advance over every other colour in the picture, crowding your model and overpowering the pose. Used for a specific graphic effect, red can make a very powerful background, but unless used with care, it can ruin an otherwise good picture. The beginner is advised to keep clear of the colour.

At the other end of the spectrum, blue is a receding colour and so makes a good background, keeping its place behind the model. It is, however, a cold colour and, for the best effect, it needs to be used with a model dressed in bright, contrasting clothes. Green is a colour that magazine publishers have, for some reason, tradition-ally stayed away from, although recently it has begun to appear more often. It's a receding colour and so makes a good background but can sometimes influence skin tones, giving your model a slightly sickly look.

Perhaps the best colour for a studio background is yellow. It is a good neutral colour that adds life to a picture, without detracting from the power of a model's pose or expression. Most other colours contrast well against it and, depending on the way it is lit, it can

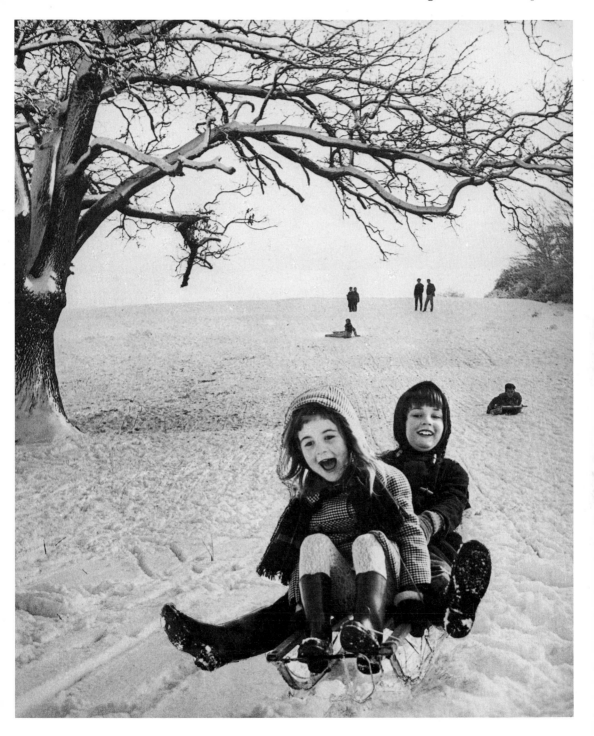

Sometimes, the background is an integral part of the subject, and then a small aperture allows you to render them both in focus.

give an infinite variety of shades from deep yellow ochre to pale lemon, all of which make excellent background colours.

The newcomer to studio work, looking for suitable background paper with which to start, is recommended to buy a roll of black, a

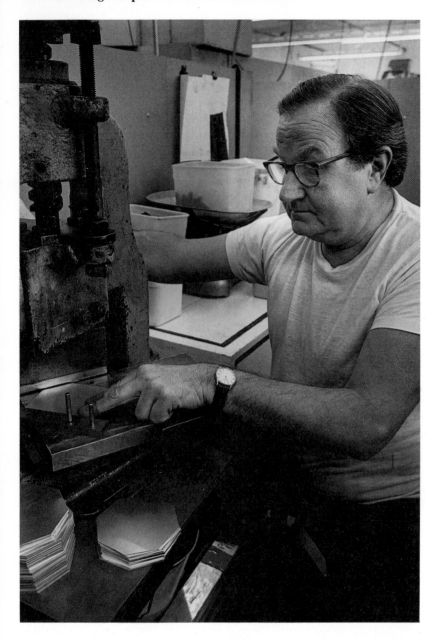

When photographing a crafts person at work, remember to keep sharp focus on both the person and the subject with which he or she is involved.

roll of white (which can be lit with coloured lights to make different colours anyway) and a roll of yellow. Those three basics will start you on the way to the sort of backgrounds demanded by professional publishers.

Backgrounds outdoors

People who want to buy pictures of themselves usually demand the formality of studio portraiture, so working outdoors, you will be shooting mostly for publication. There are two ways of handling

backgrounds outdoors: as a part of the picture, something with which your model is involved; and as a simple contrast, designed to complement your subject without detracting from the pose. We'll deal with the latter first.

Backgrounds outdoors are not easy to control. The fact that you often have to position your model according to the light doesn't help matters because what's best for the light might very often be bad for the background. So you must learn the techniques of subduing backgrounds, and the best way to do that is by differential focus: to keep your subject sharply defined against an out-of-focus background. If a background is only *just* out of focus, it will be even more distracting than when it's sharp. Blobs of light and shade that represent not-quite recognizable subjects can be very disturbing. Your aim, then, is to throw the background enough out of focus as to be unrecognizable. You do that by controlling depth of field.

Depth of field is the zone of acceptably sharp focus either side of the point on which you've actually focused. A large depth of field means that a lot of the picture will be in focus, while a small depth of field allows you to focus accurately on your subject, blurring detail in front or behind. It depends on three factors: the aperture in use, the camera-to-subject distance and the focal length of the lens. The smaller the aperture, the larger the depth of field; the closer the camera to the subject, the smaller the depth of field; the longer the focal length of the lens, the smaller the depth of field. So, to narrow the depth of field down so that your subject is isolated against a blurred background, you have three options open to you: use large apertures, move in close or fit a telephoto lens.

It is rarely possible to employ all three factors at the same time, but careful juggling of one or two can make all the difference to your picture. With the type of subject we're out to shoot, camera distance is dictated by the type of pose, and so you can rarely use that to control depth of field. Once you have decided on your camera-to-subject distance, however, you can use as wide an aperture as is possible to throw the background out of focus, or you can fit a lens of a longer focal length and move back for correct framing. Either or both will help to blur everything but the subject.

Don't forget that the depth of field you see through your viewfinder, even with a single lens reflex, is not the way it appears on the film. An SLR views its subject at full aperture, closing down to the taking aperture only at the moment of exposure. To get a realistic impression of the final effect, you need to operate the camera's depth of field preview button if it has one. If not (or if you are using a non-reflex camera), you will be forced to rely on the depth of field scale. You'll find this around your lens, adjacent to the focusing scale. It consists of the usual range of apertures on a

scale that spreads out from the central focusing spot in each direction. With the lens correctly focused, you have only to read the focusing distances as they line up against your chosen aperture on the depth of field scale. That will tell you exactly how much of the picture is actually in focus.

The second way of handling backgrounds outdoors is to make them a part of the picture. It's something which is particularly relevant to glamour photography when the effect relies as much on the surroundings as it does on the obvious physical charms of the model herself.

Backgrounds used this way should complement the pose, adding an extra dimension to the mood of the picture. The colours of the background should harmonize with whatever your model is wearing, without overpowering the picture. The composition of your picture is also important. The most important part is the model, and so the elements within the picture should be arranged so that the eye goes naturally to the face. It should then be led around the picture by various other objects and then finally returned to its principal point of interest. That's what good picture composition is all about.

If you are shooting for markets like calendars, greetings cards or travel brochures, the integration of model and background is very important and very often the background itself will make as much of a selling point as the model. If you're shooting for a market such as magazine covers or the more overt glamour such as that used on Page 3 of *The Sun*, then backgrounds should be subdued to make the most of your model.

Adding props

When does an object cease to be a part of the background and start to become a prop? Basically, when that object becomes a part of the pose. Props can be used to enhance the pose: a girl looking wistful, for instance, can be given a reason for her expression by allowing her to hold some object that obviously evokes memories – a book maybe, or a flower. A prop can be used as part of the composition: a single bloom in the model's hair for instance, might add a small splash of red to a picture whose tones are otherwise muted, giving the shot a little extra lift.

If you're aiming at the calendar market, the use of props is especially relevant. Inevitably for this particular market, we're talking about glamour photography, and the fact is that most standard glamour poses have been done to death. The addition of an unusual prop or of a girl in unusual surroundings can add a lot to the picture's worth and to its sales potential. You must, however, tread a very careful line between making the prop relevant and

allowing it to overpower the picture in its importance. Simplicity is the best approach. Make the prop a part of the pose, but ensure that it remains subsidiary to the actual subject.

Occasionally the prop is the whole reason for the picture. Let's say, for example, you are photographing a craftsman at work for a hobby magazine. In that case, the prop must play a more-than-normal part in the picture composition, probably taking pride of place in the foreground, with the actual person concerned this time

Glamour photography is an area where props are often used to good effect.

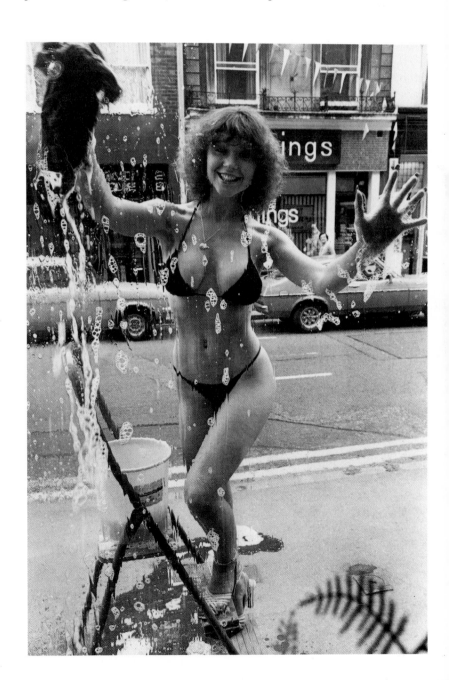

used as the subsidiary subject. One of the biggest mistakes made by the photographer who takes this type of picture and then submits it for publication, concerns focus. Inevitably he focuses on the craft itself and the person concerned with the craft goes out of focus. Sometimes it's the other way round. For this type of market you need both in sharp focus. The craft is perhaps the most saleable aspect of the picture, but the person working that craft will be the human interest which will do so much to help you sell it. So you're back to depth of field again, this time using it to extend the zone of sharp focus in the picture. Do that with small apertures and, providing distortion doesn't result, by using wide-angle lenses.

If the pose demands that the craftsman stands behind his work, don't focus on one or the other, but rather at an area *between* them that will give a depth of field on each side to keep both sharp. An even better proposition, if circumstances allow it, is to pose your subject and his work in the same plane. If, for instance, you are photographing a craftsman painting a pot, don't let him hold the pot between himself and the camera, but rather arrange the shot in profile, so that both the craftsman and his work are the same distance from the camera. Remember that when you are shooting pictures of this type for publication, you are not out to create the artistic type of picture that might win you prizes at the local camera club; all you need is a fairly straightforward record of what is going on. Keep the important areas of your picture sharp and you'll stand a much better chance of selling your work.

People as props

So far in this chapter, we've looked at how backgrounds and props can be used to enhance the people in your pictures. Now let's turn our attention to just the opposite: the way people themselves can sometimes be the props in a picture. What we're talking about here is people in landscapes.

There is a good market for well executed landscape pictures, but it's not our intention here to cover the subject in any great detail. Another book in this series, *Landscape Photography for Pleasure & Profit*, goes into the matter in far more depth, and anyone interested in this type of work is recommended to read it. The point where the two subjects cross over, however, is in the placing of people in landscapes and, without going into too much detail on general composition, it's worth looking briefly at what's required, since the addition of a person to your picture can often help to sell it.

Here, we're not looking at people as people. Instead, we're looking at them as an aspect of composition. The one thing that a person can do is provide a picture with a sense of scale. Look at some landscapes, devoid of people, and you can often be hard put

to know whether the hills in the background are giant mountains or small boulders. Add a person in the foreground of such a picture and it immediately acquires a sense of scale. We all know how tall the average human being is and, contrasted against the background, we now know how tall those hills are as well.

So people in landscapes should be used with subtlety. They shouldn't detract from the overall scene, so you are not out to draw your viewer's eye directly to them. It's a good idea if the person isn't even facing the camera, but rather faces away, looking out over the view, When you learn about picture composition, you come to understand the importance of thirds and, when positioning a person in the picture, it's a good idea to use them on one of those thirds. Never place the person dead centre. That way, the viewer will be confused about which half of the picture to look at. So place the person to one side so that his or her stance leads the viewer's eye naturally into the picture. Don't place them too close to the camera either. Position them a little way distant and use them as part of the picture composition. Sometimes if they are wearing a bright, advancing colour like red it will help give the picture a little splash of colour that will aid composition.

Finally, landscape pictures, unlike most people pictures, sell time and time again over the years, and so don't allow the person in your picture to date it with what is obviously a style of clothes or hair that will be out of fashion next year. As soon as the style vanishes, so too will your selling potential on that particular picture.

It's the small details like this that often make the difference between rejection and acceptance.

Part Two
THE MARKETS

Before You Start To Sell . . .

To sell your pictures you naturally have to be a pretty reasonable photographer. But even the best of photographers won't get rich by sitting at home waiting for customers to get in touch. You have to make contacts and, having made them, you have to convince a prospective client that you know your stuff. It's as important to sell yourself as it is to sell your pictures. So before we start to look at specific markets, let's look briefly at the non-photographic side of picture sales, at some of the ways to set yourself up, get yourself known and earn the money.

The professional approach

You don't have to be a professional photographer to be professional in your approach. Expertise aside, the only real difference between a professional photographer and an amateur is that one uses his camera for profit, the other for pleasure.

But the moment you start to sell your pictures, you are a professional, even if only on a part-time basis. Straight away, you have two major responsibilities. To your client, you have the responsibility of producing your best possible work; to both yourself and your fellow professionals, you have the responsibility of charging the right rate for the job.

Maybe you've heard it said that professional photographers frown upon amateurs coming along and taking their bread and butter away. That's only partly true. The *real* professional knows full well that if a good amateur has it in him to sell his work, there's nothing he can do to stop him. What professionals do complain about is two, very common problems.

First, there's the amateur photographer who, strictly speaking, isn't good enough to sell his work, but despite that, he does manage to sell a few pictures to people who don't know any better. This type of amateur photographer will never sell pictures for publication, but he might easily sell second-rate portraiture to people in their homes. In doing so, he drags down the profession, gets it a bad name and loses the respect of those photographers who *can* turn out the goods.

The second problem is the amateur, working in his spare time, who uses his picture sales purely as a second income and so

undercuts the professional rate for the job. Again, if we are talking about publication, you'll be paid according to standard rates and the amateur should receive the same rate as a professional, but if we are talking about markets such as portraiture in people's own homes, then it's *you* who has to set the fee. So don't set it too low. Merely taking your own expenses for the job and adding a small percentage for profit might seem perfectly adequate for a second income, but when you are a full-time professional with a lot more overheads and general expenses to consider, you need to charge a lot more, and undercutting professional rates is the fastest way there is to lose a professional photographer's respect. If you want to know the sort of rate you should be charging, ask a local professional photographer for a quote for the same job. You don't have to tell him why you want to know, but once you get his figure, you'll have a better idea of what to charge yourself.

So keep up your standards and match professional prices.

Presenting yourself

To accumulate, you must speculate. That's an old expression and a very true one. One of the things that's worth speculating over is the prospect of having some stationery printed. The two basics you'll need are headed notepaper and business cards. Add compliment slips to those if you think you'll have a need and, later, you can have invoices and statements printed. The most important, however, are headed notepaper and business cards. Don't stint in this area. Pay a good printer to design and print you something that states your name, your address and telephone number with, perhaps, a brief description of the type of tasks you undertake.

Any editor will tell you that he sits behind his desk every day, inundated with submissions from freelance photographers and writers. The sad fact, however, is that the majority of submissions appear totally unprofessional. Make your submission neatly and professionally on your headed notepaper and you will get far more attention, by simple virtue of the fact that the editor can see that he's dealing with someone who is serious about his work. First impressions, even in this day and age, still count for a lot in this business.

Presentation of your actual work is important too. If you're sending prints, do so in stiffened envelopes or packed with stiff card so that they don't arrive dog-eared. If you are sending transparencies, present them in slide wallets that hold around twenty in a single sheet so that the editor can get a general idea of your work at a quick glance. In the publishing business, at least, your first aim is to get your work seen quickly and effectively. The worst thing you can do is to wrap your submissions with a mass of Sellotape that takes an editor too much time and trouble to open.

Advertise your services

If you aim to sell privately to individuals, rather than nationally to various publications, then you'll probably be working in quite a small area, inevitably around your own home town. So get yourself known. One way is to advertise your services in the local press. A small, single column display advertisement is relatively cheap and, run for a few weeks, can give you quite a handsome return on your investment. After that, and if you give a good service, word of mouth will take over and give you a more personal form of advertising.

Having handbills printed is also a good idea. Distribute them yourself around local housing estates, or do a deal with your local giveaway newspaper to have them put through doors with the paper. Simple wording, eye-catching graphics and special offers always go down well in this area, so think up a gimmick of some sort: offering a 'free' 10 × 8 inch print if the customer orders four or more 7 × 5's is one good idea. It doesn't really have to be free of course; you build the cost into the overall fee, but you should cut the overall cost just a little to make it something special on occasions like this.

Making the approach

In situations like those detailed above, once you have advertised your services, it's largely a matter of sitting back and hoping for a response. If you're aiming for publication, it's different. You usually have to produce examples of your work in advance, either in part as just a representation of what you have to offer, or in full.

Some publications demand that you work on spec. That means you must produce a complete submission in advance and let them see it without any obligation. Others may be prepared to offer you a commission: show them what you are capable of and, if they like it, they might give you a definite job. Some, once you have sold one to them on spec, might offer you future commissions just on ideas. Whichever way you work, it's up to you to make yourself known to editors, and personal contact is undoubtedly the best.

Editors are not the unapproachable beasts that many freelances imagine them to be. Although they see a lot of work from a lot of writers and photographers, they actually see very little that is exactly right for their own market, and so they are always eager to find new talent. If you have an idea or a set of pictures that you think will suit a particular magazine (remember, we're always talking about specific magazines, *not* the market in general), give the editor a ring. Tell him briefly what you have in mind and ask him if he feels it's worth a personal visit. If he agrees, make an appointment and go to see him.

Editors are usually friendly people, but they are always very busy. So, when keeping any appointment, make sure you're on time, come straight to the point and be brief. A professional approach will always bring respect and with it – with any luck – a commission.

If, rather than attend personally, you are asked to submit your work, or if personal contact is out of the question through sheer distance, then you can of course submit ideas and pictures by post. But once again, think of things from the editor's viewpoint. Show him what he wants to see and don't waste his time. Present your pictures so that they're easy to look at and write a straight-to-the-point letter to accompany them. At the end of the day, you'll stand or fall by your pictures alone, so don't write a letter full of excuses as to why certain shots might be unsharp or not too well exposed. In nine times out of ten, it's the end product that counts, not the circumstances in which it was taken.

If you are sending prints, make sure they are of the very best possible quality, both in the original exposure and in their printing. If you're sending slides, make sure the exposure is spot-on, or even up to one-third of a stop under-exposed, but no more than that. Colours for reproduction should always be well saturated, never washed out by over-exposure or muddy from gross under-exposure.

Names of editors, together with their addresses and telephone numbers, can be found in *The Freelance Photographer's Market Handbook*, published by BFP Books.

Making the sale

We've already covered the point about working for a professional rate when you are selling privately; when you're selling to a publication, providing it's a reputable one, you should automatically get a professional rate. The catch is that the rate will vary with the publication, from no more than a few pounds from a local newspaper up to perhaps £100 or more per picture from a big national magazine. Unless you are already a well-known name, you'll have little or no bargaining power here, and you will inevitably have to accept the rate that's offered. The exception is if you have some picture that is worth a lot of money to a lot of people – some famous personality in unusual or particularly newsworthy circumstances, for instance, which the national press are keen to get hold of. In which case, you could find yourself in the enviable position of being able to sell to the highest bidder, perhaps even for exclusive rights to publish the picture.

But in normal circumstances, you should sell only one time reproduction rights. That means you keep the copyright of the picture and the publication buys the right to use the shot once only.

Probably the best way of presenting colour slides is in plastic filing sheets. They allow editors to take a general look at your work before moving in for closer examination of individual pictures.

You are then free to sell the picture elsewhere, but here you must use discretion. Although there is no law against it, you would be foolish to sell the same picture twice, and at the same time, to rival publications. You might get away with it once, but you'll soon find yourself on an unofficial blacklist with the publications you were dealing with. What's more, news like that spreads and you could find that if you've got yourself a bad name with one editor, he has spread the word, even with his own rivals.

What you *can* do is sell the picture more than once to different markets. A picture which, for instance, might have been used in a book, could also be sold to a magazine. You might also sell the same picture to two magazines in different fields of interest. A lively portrait for instance, might sell for the sake of its subject to a women's magazine and for the technique involved in shooting it, to a photographic magazine. It doesn't hurt too much to sell pictures to rival publications a few years apart either, providing they are not being used for too similar reasons.

If you sell one-time reproduction rights like this, and providing the publication concerned makes you a fair offer, it's best not to haggle with them the first time. It is, however, a good idea to make sure you know what their standard rates are before you agree to let them use your pictures. Some publications do have notoriously low rates and you should know what you are letting yourself in for right at the start. What is considered bad form, is to allow your pictures to be used, then to complain about the fee after publication. If the fee you receive at the end of the day is lower than you expected, you should really only have yourself to blame for not checking at the time of acceptance. In such circumstances, don't argue – just write it off to experience, and remember to check next time round.

What is worth remembering is that some magazines have a dual payments scale: one for first-time contributors and one for their regulars. So once you have sold to a particular market a few times, it's worth making the effort to renegotiate your fee.

Many magazines work on a self-billing invoice system. That means that, once they have accepted your work, you are required to do no further paperwork. In theory, they write an invoice for the fee, from you to themselves, then send you a cheque with a remittance advice. Some publications, however, might ask you to invoice them. You can buy books of blank invoices from stationery shops, or you can use nothing more than a piece of your own headed notepaper or even just a blank piece of paper. Whichever method you use, the invoice needs to carry your name and address, the name and address of the publication or publishing company you are invoicing, brief details of the work supplied and the fee.

If you earn enough from your freelancing to register for VAT, then you *must* supply an invoice, whether the company concerned operates the self-billing system or not. On that, you must charge the basic fee, plus the added percentage for VAT (15 per cent at the time of writing) and quote your VAT registration number. The company with whom you are dealing will have no objections to paying you VAT on top of the normal fee, because, providing they have your VAT number, they can claim the extra back from the government. You, on the other hand, must pay the VAT earned on every fee, as well as the usual taxes. In effect, the publisher takes the VAT from the government, gives it to you and you give it back!

If the work you are selling is commissioned for definite use, you should deliver your invoice with the order. If not, you should issue it as soon as the work has been accepted.

When you deal with private sales, rather than those for publication, then you should issue your invoice together with the pictures when you deliver them, or when the client collects them. If you take pictures for private sale like this, you should not try to sell them for publication as well without the permission of the person who asked you to take the pictures, but with that permission granted, separate sales can be quite lucrative. Pictures of children, taken for private sales, can often sell to mother and baby type magazines; pictures maybe taken for a hairdresser might easily sell as cover shots to other types of magazine. But remember your initial duty is to the client who commissioned you to take the pictures in the first place. Never sell this type of shot elsewhere without prior permission.

Very occasionally, a major publication or perhaps a picture agency might want to buy the complete rights in a picture from you. If you are dealing with a reputable company who have genuine reason for wanting the rights, that could be extremely

lucrative. If you do sign away your copyright of course, you must not sell the picture or even one that's very similar anywhere else on your own behalf. Remember that when you negotiate the fee for total rights and don't let them go if you think you can make more money out of the picture from your own contacts.

Be especially careful of the small concerns that try to take complete rights in a picture for no more than a few pounds. Avoid such people like the plague. Unless you take a picture for your employer, you always own the copyright and, unless the circumstances – and the fee – are exceptional, it's usually wise to retain your copyright, selling only the various rights to publication.

If you want to go into this subject deeper, or read up on any other points of law as they affect photography, you should read *The Photographer And The Law*, published by BFP Books.

Selling to the Public

The potential freelance, looking for a market for his pictures, inevitably considers publication of some sort. But there is another very big, and often neglected, market for pictures sold direct to the public. It's possible to set yourself up as a local photographer, offering your skill with a camera and lights, in much the same way as the local carpenter offers his skill with a saw and hammer.

No subject is better suited to this way of working than people. You are taking pictures *of* the subject, *for* the subject. Here are some of the places that you might make easy sales with this way of working.

Local drama groups are good targets for private sales, and the pictures you take could easily sell to the local newspaper or to national magazines at a later date.

Hairdressers

Fashion changes constantly; so too do hairstyles – especially women's hairstyles. So the local hairdresser, wanting to keep up to date and to keep his own talents constantly before the public, has a steady demand for pictures to display in his salon. Introduce yourself to a few in your town and you could find that, not only have you found a new market, you've also discovered a very good source of potential models.

Mostly, the pictures will be of girls, wearing the latest hairstyle; but there will also be a smaller market here for male portraiture in both men's hairdressers and in the unisex salons. The type of picture that's needed will be fairly plain and straightforward. The hairdresser doesn't want arty lighting or special effects. He wants a good, detailed picture that shows his latest creation to its best.

It's rare that pictures of this type can be taken in your own studio, simply because the hairdresser will want to create the style and have it photographed immediately. As such, he needs to be in his salon, and you need to be adaptable. He may have a separate room behind the salon in which you can set up your mobile studio, but it's a fair bet that you'll have to work in the salon itself, after closing time.

You'll need simple, basic lighting and a portable background. Because this market is exclusively for head and shoulders pictures, this is one place where a small projection screen can be used behind the subject. Keep lighting on the face simple – one flash bounced

into a large brolly will be adequate – and use your extra lighting to highlight the hair. A single flash, fitted with a snoot, either above the model's head, or above and behind her at a 45 degree angle, will be fine. Don't be tempted to put the light right behind her head to draw a halo of strong light around her hair: it might make an effective picture, but it won't show the hairstyle to its best, and that's your prime consideration in this market.

You'll find that the hairdresser probably has his own list of girls who regularly submit their hair to his experiments, so you won't need to provide models. The girls, however, probably will not be professionals, so your skill will not only be with camera angles and lighting, but also in coaxing the best expression out of amateur models. The pictures you are taking will be mostly for display in

the salon, on the walls and in the windows, and customers won't want to see scowling faces demonstrating the latest hairstyle, so work to get your model relaxed and go for simple, smiling expressions.

This market will essentially be for large colour prints, so stock up with colour negative film and, if you have the choice, use medium format rather than 35mm. Take some black and white film too because, very often, if the hairdresser has an extra-special style of his own, he might want to send a picture of it to one of the hairdressing magazines, and he might need black and white prints for that. And take some colour slide film with you as well for your own use. With permission of both the hairdresser and the model, you might find you are taking pictures that you'll be able to put to your own use later.

The cover of this very book is a perfect example of that. It was taken for a hairdresser, in the crowded atmosphere of his small salon. A projection screen was used for the background and the model was lit by just two lights – one bounced into a silver brolly at about 30 degrees to the left of the camera, the other directly opposite and above the model through a snoot directed at her hair. The picture was used by the hairdresser for the salon wall but since then, it has been used as a cover shot on a national monthly photographic magazine, used in another two magazines – one photographic, the other non-photographic – to demonstrate photographic techniques, and it has won a major prize in a national photographic contest. Counting the cover of this book, that's a total of six markets for one picture.

Drama groups

Every town has a drama group, some amateur, others professional, and they all need pictures. A market like this can be especially lucrative, simply because there will be so many outlets for each of the pictures. The group in general will want prints – usually colour – for front-of-house stills, the individual actors will order separate pictures for their own use and there's a wide potential for extra sales, particularly in amateur productions, to the families of the people taking part. There's also the chance of additional sales to local newspapers in the form of mono prints.

Your point of contact is the producer for permission to shoot. The best time to take your pictures is at the dress rehearsal. By that time, the actors will know the play and they will be in costume. It's a good idea, however, to watch an earlier rehearsal to get an idea of the action and what sort of pictures will make the best shots. Then, at the final dress rehearsal, you can shoot from the audience.

It's rarely a good idea to take your pictures from the front row,

since this will inevitably mean looking up at the stage and the actors. Instead, get a little way back and shoot with a slightly longer-than-standard lens. There will be plenty enough light from the normal stage lighting for hand-held exposures, and you will be able to shoot as the action naturally progresses. But watch the *direction* of the light. If an actor gets too close to the footlights, they can turn a face into a death mask that is not only uncomplimentary, but will also result in a totally unsaleable picture. Stage lighting is also extra harsh, so watch contrast and, if you are shooting in black and white, compensate for it in processing by over-exposing slightly and under developing the film.

Take a notebook with you and make notes of interesting pieces of action as the play goes along. Then, later, you can ask the actors to set up certain pieces of action again and, this time, shoot from the stage itself, using flash if necessary. If you want to pose specific shots like this, always do so at the end, never interrupt the rehearsal while it is in progress.

If, on very rare occasions, you are reduced to having to shoot at an actual performance, do so as unobtrusively as possible. Don't get in the way of the audience, never use flash and keep your activities very quiet.

Weddings

Wedding photography – just another branch of people photography – is a very real art, and one from which many photographers make a full-time living. This is one area where you really do have to be professional, both in your approach and in the fee you charge. Undersell your services in this market and you'll have every wedding photographer in town on your back.

Unlike most forms of portraiture or people photography, you really do have to get this one right first time. If something goes wrong in the studio, you can always apologise and ask your subject to come back for a reshoot. If something goes wrong with a wedding, you can't ask the couple to get married all over again!

Most photographers in this line have a link-up with a local studio. There are two reasons for this: the first is that the studio will take the bookings and then contact the photographer with a firm order; the second reason is the processing, which can be taken care of by the studio. One of the major selling points in wedding photography is getting the film developed, proofed and back to potential customers before the reception is over. That's where you'll take most of your orders.

When you're covering the actual event, work quickly and methodically. Get in mind exactly the sort of poses you want and keep everyone in order. You'll want a traditional picture of the

bride and groom, another with the best man, another with the bridesmaids added, another with immediate family and another still with all the guests. It's often a good idea to enlist the help of a major guest who knows the people concerned and who will help you marshal everyone into the right place at the right time. Covering a wedding can be more like a military operation than real photography.

This is a market where you can sometimes sell the slightly unusual or off-beat type of picture, but never take that sort at the expense of the standard, corny and traditional wedding shots, because those are the pictures that will sell. Take the normal pictures first and, if you have time, experiment later.

If you are working with an established studio, they will have all the extras which help to sell wedding pictures, on hand. If you are working alone, get in contact with a firm that makes albums and simple folders. Get a choice of several albums that you can show clients. The guests will order individual pictures which should be presented in folders, printed discreetly with your name and address, but the bride and groom will probably want their order specially mounted in an album.

Wedding photography is highly specialised and always a great responsibility. It's not a market for the faint-hearted, and if you have any doubts about it at all don't even attempt it.

One final point. If you *do* attempt it, try to keep a private file of negatives, showing brides and grooms! They could be used years later by a newspaper. Most people in the news got married at some time in their lives and when all other attempts to get a picture of a newsworthy person fails, newspapers, both local and national, will often turn to the local wedding photographer to see what his files turn up.

Schools

Children at school are a good target for the freelance, and this is one place where the special offer approach goes down well: buy four prints, get one free; buy three 7 × 5's and get a free 10 × 8. With offers like those, you have only to consider the number of children in the average school and multiply that by the number of pictures that each family will order to see just how lucrative the market is.

Colour prints are the order of the day here, and your sales will come, not from orders placed in advance, but from the actual pictures. Work like this.

Take some pictures of your own, or a friendly neighbour's children and hawk them around the local schools, approaching head teachers for permission to come in one day to shoot. When the appointment has been made, take a simple studio set-up with

you – a portable background and one flash unit with brolly is adequate – and ask permission to set up in the school hall. The alternative is to set up separately in each classroom, which is time-consuming. Using colour negative film, take the minimum amount of pictures of each child, just ensuring each time that you have a nice, happy expression. Ask in advance about brothers and sisters attending the same school and arrange to shoot them together. Watch out for grubby faces and running noses – two very common faults guaranteed to discourage sales.

Don't attempt to take orders there and then. Instead, have the pictures processed, or process them yourself, and present them in a neat package – three small prints and one large one is a good way. Quote a price for the package on the wrapper and include a separate order form for extra pictures. Then take them back to the school and have them distributed by the teachers with instructions that parents should send back money if they want the pictures, or the pictures themselves if they decide against it.

Once the parents have seen the pictures, they will be far more inclined to buy them than if you'd asked them for orders in advance.

Private portraiture

There is a good market for private portraiture, either of individuals or of family groups. You can operate from your own fixed studio, or with a mobile set-up that you take into people's homes. Either way, details of the equipment you'll need and basics of posing have already been covered in the first part of this book.

Taking pictures of people for their own use is a little different from taking portraits for *your* use or for publication, for that matter. You are not out to produce an artistic piece of photography, but more to produce a true representation of how your subject looks – or, perhaps more important how he or she *thinks* they look.

You need to work at bringing out your subject's character, but only if it is a likeable character. You must disguise defects in ways we've already covered, add a little soft focus here and there to ladies of more mature years, show the customer himself or herself the way he or she wants to be seen. Lighting can be kept to basics because, at the end of the day, the market is purely for the person, not for any artistic effect you, as a photographer, would like to see used.

If you are working from your own studio, welcome your client with a cup of coffee and a little chat before starting the session. Remember that photographic studios to the inexperienced can still be rather frightening places, so introduce them into the session gradually, asking if they have any ideas of their own about the type of picture they want, or telling them about the way you aim to work and the sort of result they can expect to see.

When you are working in the client's own home, consider their feelings. Look at things from their viewpoint and act accordingly. Remember that you are a stranger, walking into their house with a lot of strange equipment. Spend half-an-hour unloading gear and erecting it in the lounge and you will generate a feeling of tension. Your subject will begin to feel nervous and that isn't going to help your pictures. Apart from which, you don't really need the inconvenience of having to carry and erect a lot of equipment.

Two flash heads with brollies and/or diffusers, a portable background of some kind plus a camera with a standard lens and another of twice its focal length are all the equipment you really need. The usual market will be for colour prints of different sizes, and there might also be a market for prints made on slightly out-of-the-ordinary printing papers. Papers are available with textures that resemble oil paintings – a particular favourite in this market.

When you arrive at your client's house, be efficient, cool and calm. Put them at their ease. Bring out your equipment and erect it quickly and methodically. Clear the largest space possible in the room, hang your background and find a suitable seat for your model. Keep the session brief – time is money – and exude confidence throughout.

Finally, a piece of advice that has little to do with actual photography, but everything to do with being a good businessman. Whatever the job, don't keep your customers waiting for their pictures. If the job demands proofs, return as quickly as possible, while the photo session is still fresh in their minds. Leave the proofs so that they can look at them in private and call or telephone a few days later to take their order. Then deliver the job, with your invoice, as soon as possible.

The more efficient the service you offer, the more you'll find yourself being recommended – and that's the best kind of advertising there is.

Shooting people in their own home can be lucrative if you take a professional approach. You can carry a portable background to give the impression of a real studio, or use the subject's own home as the background.

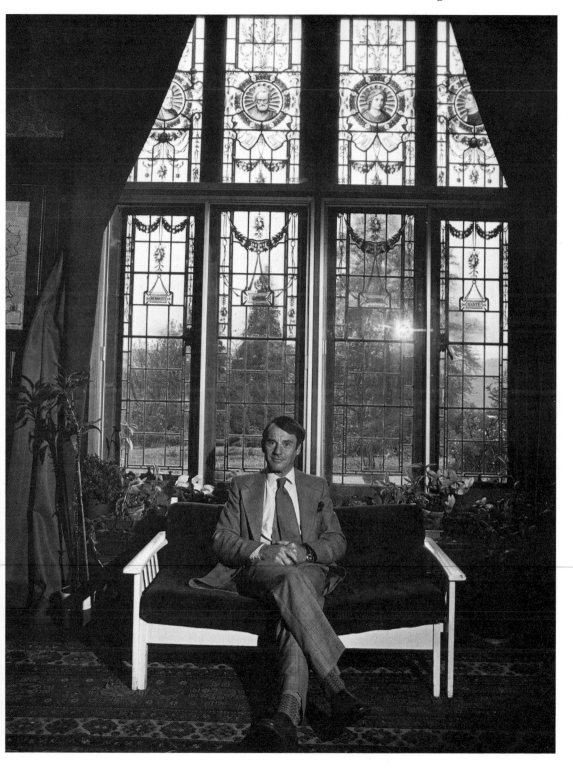

Selling to Newspapers

Perhaps the most attractive market for your pictures is in some form of publishing. No matter how long you've been freelancing or how often you've had pictures published, there is still a thrill that comes with seeing your work on the printed page, with the sure knowledge that thousands of other people are seeing it too. There are many different outlets in publishing for your pictures, but perhaps the most popular are magazines and newspapers. We're going to look first at newspapers, how to overcome some of the problems inherent to this market and how to take the type of picture their editor will want to buy.

Local newspapers

Straightaway, we're on uneasy ground. Local newspapers in general have a notoriously bad reputation among freelances, both for non-payment and for an apparent disregard for a photographer's work. To understand why those complaints are often justified and to see how you might overcome them, it's wise to learn a little about the way a local newspaper works.

Most local newspapers are self-contained units. Unlike many magazines and most other publishing outlets, they have all the staff they need to produce the complete product actually on the premises, from the most junior of reporters right up to the machine minder who prints the paper. In the normal, day-to-day running of the office, they have no real need for freelances and because of that, they are simply not geared up to handle them. And because they have their own staff, they rarely have a very large extra budget to buy in pictures from outside.

A small newspaper, or one of the freesheets that have risen so much in popularity over the past few years, might have an editorial staff of no more than an editor and a couple of reporters. But a large, professionally-run newspaper will have a much larger workforce. A typical staffing level might be an editor, who oversees the whole publication; a deputy editor, chief-sub and one or two downtable subs, each of whom is involved in page production; a news editor, who controls the actual news gathering; about ten reporters, ranging from juniors to senior men and women; and a couple of staff photographers.

Send pictures into them on spec and they will arrive on the news editor's desk. If they are of no use, it's a good chance he will discard them without even the courtesy of a reply. It's not that he is impolite, but more that he is a very busy man, who has no secretary to look after things like that and who, five minutes after he has pushed an item aside, has probably forgotten about it. If your pictures are of use, they'll probably get passed through to the subs desk and, in turn, sent down to the printer within a few hours. And it's a fair bet that your personal details will have disappeared with them so that, when they are published, no one knows who took them, which is why you fail to get a fee.

All of which paints a pretty grim picture of local newspapers. Yet, it is possible to sell to them and to make regular money, if you

Local newspapers like local personalities, but there must be a news angle to the subject to make it sell.

know how to go about it. What's more, look at any local newspaper, and what type of picture dominates the rest? People. By now, that's a subject in which you should be an expert.

Your first task is to make yourself known to the editor. Go in and see him on a day when you know he won't be too busy. How do you know when that will be? Very simple. Pick the day *after* the paper is published. The staff get busier and busier as they work through the week towards press day. Introduce yourself, show the editor some of your work and offer your services.

Then, when some newsworthy event is coming up in your locality, telephone and ask if the paper would like it covered. It's a good bet that they won't because they will already be sending one of their staff photographers along. But if the staff man is busy elsewhere, then you might easily get the go-ahead. Once that has happened a few times, and if your work is up to scratch, then you

could find yourself being called on more and more as a stand-in for the paper's staff photographers.

If your pictures are published and no cheque is forthcoming, then telephone the editor with a gentle reminder. Always remember that he isn't geared up for paying freelances in the way that, say, a national magazine might be, and oversights can easily happen. The money you earn from local newspapers won't be enormous by other publishing standards, but it should be worthwhile. If it isn't, don't work for that paper again.

People provide the human interest that is at the very core of most local newspaper stories, but to make a newsworthy picture, they need to be *doing* something. Rarely will the straightforward portrait type of pose work here. Local newspapers seem to be full of people shaking hands with each other for various reasons, so see if you can find a variation on that traditional pose. If someone has won a cup, don't picture him merely shaking hands with the prize-donor, shoot him grinning from ear to ear and holding the cup aloft. If you *are* reduced to the old hand-shaking routine, here's a good point to ponder. When people actually shake hands, they do so at arm's length. On a photograph, that means two people, one each side of the print, joined together by their arms and with a lot of wasted space between them. Newspapers loath wasted space. So when you photograph hand-shakers for newspaper pictures, get them to move a lot closer together than normal.

Local newspapers are full of groups of people: from football teams to women's institute members. Again, don't just shoot a row of blank faces, get them involved in some activity. If they didn't *have* an activity, they wouldn't be in the paper in the first place, so find an angle and exploit it.

If you know the local paper is actually covering an event themselves, there is little point in going along and trying to beat the staff man at his own game. Even if you take a picture better than his, they'll probably use their own, simply because the staff man has been paid for the job. That aside, however, there *is* a way to beat local newspaper staff photographers, simply by going to places that they won't go.

Local papers are notorious for sticking firmly to their own areas and staff photogrpahers rarely stray outside their own districts. That leaves you free to score by photographing people, local to some other area, away from home. The *Local Boy Makes Good* type of story is one that most local papers like to run, so if you can find some hero who is local to you, but who originates from some other area, you could be on your way to a sale to the paper in his birthplace, or in the town where he was brought up.

In that, we could be talking about papers as far away as the other end of the country, or as close as the next town. When it comes to

Nationally-known personalities will often visit your area and they are always news. This small selection of pictures were all taken by a freelance photographer within the confines of his own locality.

travelling expenses, it's amazing how ready editors are to draw boundaries around their areas and forbid their staff to cross them.

Obvious targets are events in the public eye: talent shows, baby shows, beauty contests, military displays, anything in which people are doing things that are newsworthy, the sort of thing that you are used to reading about in your own local newspaper.

Once you have your picture, approach the person or people concerned for a few words that the newspaper will be able to turn into a caption: name, age, address and details of the event in which he or she was involved. You'll find the names and addresses of all the country's newspapers in a publication called BRAD – that stands for *British Rate And Data*. There's probably a copy in your local library. If not, you might be able to purloin an old one from the advertisement department of your own local newspaper if you speak to them nicely.

If you try this type of sale, you are of course back to the old problem of submitting pictures on spec and, as we've already seen, that's not terribly easy with local newspapers. But if you have a picture that you think they'll use, ring the editor first, introduce

Even in news events such as this one, a little human interest will help your pictures sell.

yourself and ask if he'd like to see it. If he says yes and the paper is too far from home for you to see a copy, ring again a week later to ask if they published it. If they did, send an invoice, It should produce a cheque within a week or so.

Just because a local newspaper only comes out once a week, don't assume that you have plenty of time to get your pictures to them. Good locals can have as many as three deadlines in one day towards the end of their press week, and even at the start of the week, they will be getting pages away to the printer once or twice every day.

If you are asked to cover an event one evening, the results should be on the news editor's desk the following morning. If the paper is being printed offset litho, you can supply your prints any size you like within reason, because the production process allows them to be scaled up or down. But if the newspaper is more old fashioned, printing, as many of them are, by letterpress, there's a good chance that they'll need their pictures supplied to the printer in standard column widths, to be reproduced same-size on the page. If that's the case, and assuming they have their own darkroom, they might prefer a contact sheet and the original negatives to actual prints. That way, they can produce the picture themselves in exactly the width they require. Alternatively, they might ask you to produce the picture for them. They'll give you the depth of the picture in inches or millimetres, but you might find them talking about the width in terms of ems.

An em is a printer's measure and it is used to designate widths of type and pictures on the printed page. To get things absolutely right, you can buy a printer's gauge from printing suppliers, or you can measure the widths of standard columns in the paper you are working for and translate them into inches or millimetres for your own use. As a general guide, however, there are six ems to the inch.

National newspapers

Don't be under any illusions here. National newspapers are difficult areas for the unknown freelance to break into. But don't be discouraged, it can be done. Apart from news story pictures, four types of subject are reputed to sell best to this market: animals, Royalty, children and glamour. Significantly, three out of the four on that list involve people.

To get your pictures into the national press they must be either newsworthy, or of strong human interest for feature material. What we said about staff men on local newspapers is doubly true for nationals. They have a tremendous workforce of photographers, each ready to go to any part of the country or even the world – at a moment's notice. To beat them, you have to produce a better picture, and you have to be *good*. Unlike many local newspapers,

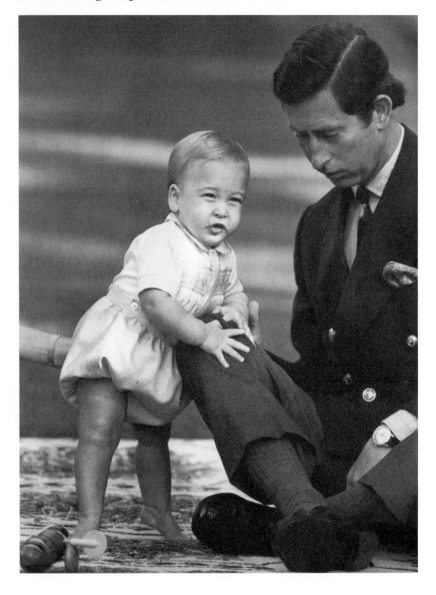

Not the sort of picture that th
average freelance would have
the chance to take, because it
was taken on an official photo
call for the national press. But
if you can record Royalty in
your pictures in any way,
you'll always increase your
chances of success with local
and national newspapers alike

however, the best pictures in this market will usually win out in the
end, whether they are by staff or freelance photographers. So if you
do beat the staff photographer with a better idea, you stand a good
chance of publication.

You stand your best chance of selling people pictures to national
newspapers if you are around when some unexpected newsworthy
event happens suddenly, giving you the chance to get pictures
before the staff man gets there.

By newsworthy, don't be misled into thinking you must look for
some big, dramatic event. Something far simpler could just as easily
make you a sale. Supposing a member of the Royal Family is
visiting your area for some simple ceremony that the national press

National news stories have to happen somewhere and, if they happen near you, your camera might be the only one around to record the event. That's when you'll make sales to national newspapers.

aren't covering in any great detail. Supposing you are focusing on the Queen, and her hat blows off, causing a funny or surprised expression, not usually seen in Royalty. Get that expression on film and you stand a chance of selling your pictures to any paper in Fleet Street. The same might go for a famous film star or pop personality who is passing through your area.

If you do have a picture that you think will stand a chance with the nationals, speed of delivery is very important. Don't bother to develop the film, don't even bother to go home; go straight to the nearest phone box and contact the newspaper of your choice. All the national dailies are listed in the London telephone book; if you don't have access to that, get their numbers in advance from Directory Enquiries and keep them with you in your camera bag.

When you get through to your chosen paper, ask to speak to the picture editor. Introduce yourself and tell him briefly what you've got. If he's interested, he'll tell you to get the film to him. If he isn't interested, don't bother him any further. Hang up and try another paper. If you live within an easy distance of the paper concerned,

take the film there personally. If not, arrange with the picture editor to have it picked up from the nearest railway station and Red Star it to him.

Either way, the newspaper will prefer to develop and print the film in their own darkroom, so don't be tempted to start processing it yourself. Don't waste time. The newspaper can handle processing much better and much faster than you.

One area where the freelance does stand a chance of breaking into national newspapers, and without all the hassle of finding news stories and getting pictures delivered on time, is in the glamour field. Again, many newspapers have staff men or their own favourite freelances who produce exactly the type of shot they

One area that is open to the freelance, aiming at national newspapers, is in the field of glamour.

want, but there is always scope for the newcomer with new ideas – providing they conform to the overall style of the paper's pictures.

Market research is all important. Don't just shoot any type of glamour picture and hope to sell it. Pick a specific newspaper and study its content during the course of, say, one week. You'll find the sort of glamour pictures they use are stunningly similar and, once you've absorbed their style, you'll be ready to shoot and submit.

Since we're not talking about speedy, newsy pictures, you can send prints in for this market, but remember that in doing so you are competing with other prints on the picture editor's desk, shot by staff men and from their own darkrooms. The quality of those prints is going to be superb and the size is probably larger than you might expect, often up to 15 × 12 inches. The pictures should be bold, simple and straightforward, with plain backgrounds, both in the studio and outdoors. This is one market that goes heavily for strong back-lighting to highlight a model's hair and skin texture.

Poses conform to fairly rigid styles. The girls must look glamorous but not offensive, sexy but smiling. Keep in mind the fact that the pictures are for mass family readership. You have to strike exactly the right balance between sex and taste. The newspaper will also want a few personal details about the girl: her name, age, vital statistics and anything about her that will give them an angle for a caption – an unusual hobby or ambition, for instance. If she doesn't have an angle, other than her obvious physical charms, get her permission to make something up.

Working for any newspaper, local or national, you will naturally be shooting for mono reproduction, so stick to black and white films of medium and high speeds. Use the traditional emulsions like FP4 and HP5 or Tri-X rather than the chromogenic types that take longer and are more difficult to process when speed is of the essence. Keep your pictures simple and to the point. They will be printed on coarse-grained newsprint in which most subtleties of tone will be lost, so go for a good contrast in the original, be it a negative or a print, and make sure your subject is well-defined in front of the background. Subjects and background of actual different colours, but which turn into similar tones of grey on a mono print, do not reproduce well in this medium.

The experienced eye of a newspaper picture editor will know exactly which pictures will and will not reproduce well, and make no mistake, unless yours match the requirements exactly, they won't stand much chance of publication.

Selling to Magazines

At the last count, there were close on 7,500 magazines published in Britain alone, and the hard fact is that the greatest majority of them use freelances. Unlike newspapers, many magazines work with a small overall staff in the office, relying on freelance writers and photographers to fill their pages. When a magazine does employ a large staff, it will include a number of writers; staff *photographers* are a lot more rare.

Visit many national magazines and you'll find a surprisingly small office with just two or three people in it. They make up a production unit for handling other people's words and pictures. In order to survive, they need to be constantly supplied with new material, and that's where you come in. Send them the right kind of work and you will sell to them time and time again.

Most magazines are aimed at specialists in some field or another, be it a hobby, a trade or a profession. Even women's magazines which, at first sight, seem to be universally concerned with general interest for women will, on closer inspection, reveal individual biases towards different *types* of female, from teenage to middle age and on to old age. Selling to magazines demands that you carry out a detailed market analysis before you start.

The words *market analysis* tend to frighten many people. If you're among them, take heart. There's nothing complicated about the procedure as we're applying it here. It involves no more than learning how to look at magazines in a rather different way to the one you might be used to.

Let's start with a few points about the magazine market in general.

What they buy

There are three basic types of picture with which you will be familiar: black and white prints, colour prints and colour transparencies. Magazines can use all three, but in practice, you'll find they are really only interested in two: black and white prints and colour transparencies. Colour prints are almost impossible to sell. This is mainly for reasons of production. While it is possible for a printer to obtain a colour reproduction from a print, the exercise is slightly more complicated than it might be with a transparency, it is often

more expensive and, at the end of the day, the quality isn't as high. Occasionally the photographic press might accept a colour print and sometimes, a magazine will make a black and white reproduction from one, but on the whole, it is unwise to submit anything but mono prints or colour transparencies. The very worst thing you can submit is a set of colour enprints. These will not sell in any but the most exceptional circumstances.

Most magazines have colour covers, and inside contents that are mostly black and white with some colour. There are exceptions of

The craft and hobby magazine market is vast, and every publication is in need of illustrations for articles.

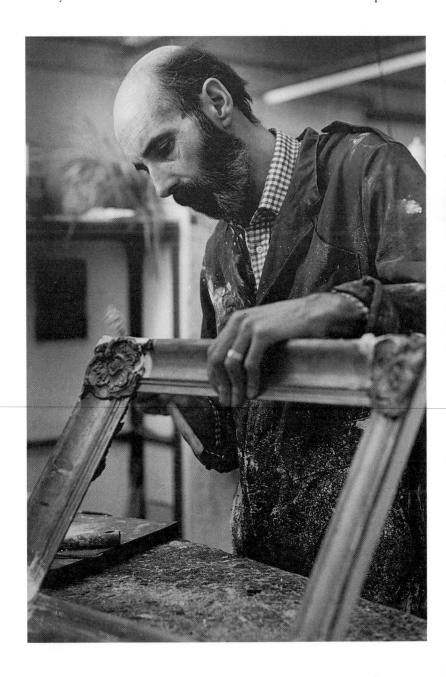

course – magazines that use no colour at all, even on the cover, or magazines that use no black and white. But the average magazine uses a mix of the two, the greater proportion given over to mono.

In such markets, the colour pages are usually reserved for subjects that demand colour to get some point across. If a subject can be covered with equal effect in black and white, then it will be consigned to the mono pages. You should think the same way in your submissions to your chosen market. These days colour is so much more convenient than mono that it is tempting to shoot nothing but slides. If you do that, however, you are ignoring what is still the largest slice of the magazine market: mono prints. So

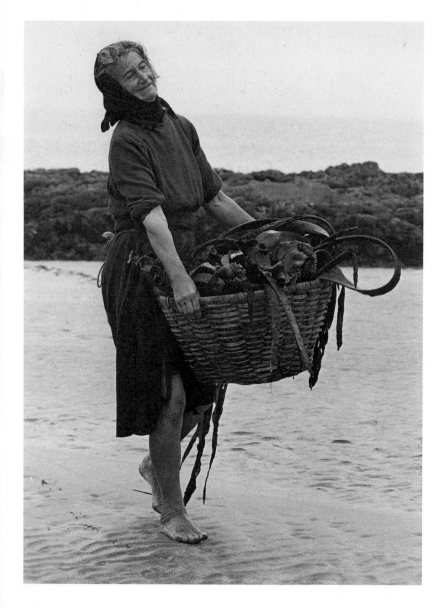

A picture that would not necessarily sell in its own right will often make sales as an illustration to an interesting article.

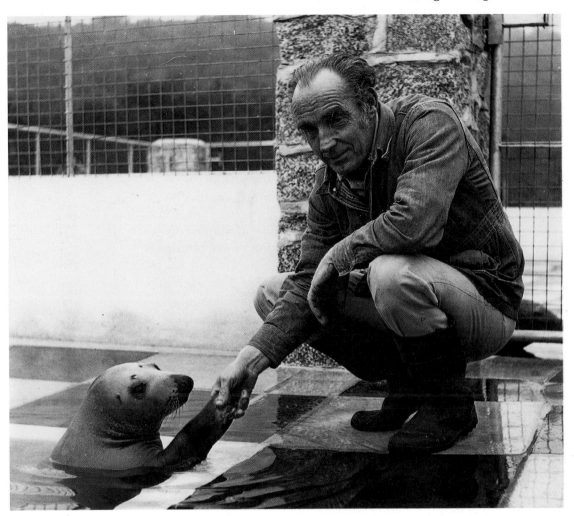

County magazines are always interested in pictures of local personalities or local people involved in some unusual or interesting activity. The market is mostly for black and white.

remember, if your subject doesn't *need* colour, you'll usually stand far more chance submitting your pictures in black and white.

Different magazines obviously want different subject matter in their pictures but, on average, the needs of most magazines can be broken down into five basic categories of picture.

The first of these is the single picture which, with a caption, tells its own story. That can range from things like craftsmen working on unusual projects in a craft or hobby magazine, to perhaps nothing more than a pretty girl for a more general interest market. In this type of contribution, the whole point of the story must be shown by the picture. It shouldn't need additional explanations to get the point across, although it will need a short, descriptive caption, and the story behind the picture should be concerned with the sort of subject that wouldn't stand up without the picture.

The second category is the article illustration. In many ways, this

is exactly the opposite of the first example above. Here, the main point of the contribution is contained in an article, while the pictures are only of a secondary importance to illustrate and support the words.

Our third type of submission is the picture story. This is a sort of cross between the first two categories. Here, the point of the submission is carried by the pictures. They tell a specific story in the way the words of an article might. They do of course need words with the pictures, but what differentiates this type of submission from the illustrated article is that the idea being put across is essentially pictorial; the pictures come first and words are used as the back-up.

Next comes the step-by-step picture sequence type of submission. These are used to show readers how to perform or undertake certain tasks. Many such sequences don't need people at all and are therefore outside our subject area: a sequence for a motoring magazine on stripping down a carburettor, for instance, might need no more than a series of pictures showing the device, lying on a bench, in various stages of being dismantled. On the other hand, many step by step sequences *do* require people, to maybe show how a piece of equipment works or how it might be put together.

Lastly we come to the file picture. This is a very general type of illustration that can be used by the publication to perhaps fill out an article that lacks the right sort of example for a particular feature. A picture of a baby being bathed, for instance, might easily be held on file by a mother and baby type of publication and later used to illustrate articles that could vary from how to bath the baby to perhaps another on different types of shampoo or bubble bath for children. It could even illustrate a feature on children who are scared of water!

So those are the types of picture that you can sell to magazines. But before you do actually start to sell, you've got to turn those *types* into *specifics*, and to do that, you must learn a lot more about your actual chosen market. This is where your market analysis begins in earnest.

Analysing a magazine

Your first task is to pick a *type* of magazine. In any subject other than people, your choice would immediately be restricted. But with people photography, your choice is as wide as the magazine market itself. Whatever the overall subject a magazine aims itself at, people will be involved somewhere along the line. Crafts? Someone has to perform them. Motorbikes? Someone has to ride them. Photography? People make marvellous subjects. Women? They *are* people. You can't escape people in any form of publication.

Soft-core glamour can
often interest the general
interest market, and even
some women's magazines.

One thing that this book has been keen to drill into would-be freelances is the way you should work towards finding pictures for markets, rather than markets for pictures. That holds as true with the magazine market as it does with any other, but with such a wide choice of publications for your pictures, you must begin by making certain concessions to your own photographic preferences. If, for example, you know that you're good at studio pictures of pretty girls, there would be little point in trying to adapt your style to a magazine whose speciality is car maintenance when, next door to it on the news stands, there might be a magazine on hairdressing to suit your style so much better.

So start with a general analysis. Look for magazines which cover subjects that you know yourself to be capable of photographing.

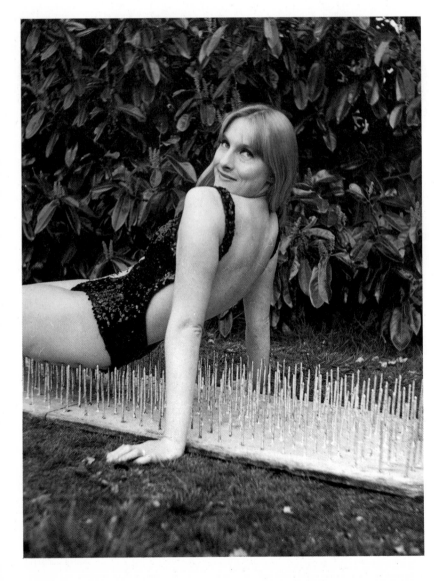

Women involved in unusual or interesting activities make good features for the women's press—and they all need illustrations for the words.

Children sell well, if shot in the right way and aimed at the right market, but make sure the pictures have a real sense of purpose, rather than merely depicting a family-type snapshot of the kids.

Having sorted out that generality, then you can begin to close in on your intended market. Pick a subject – photography, women's interests, arts and crafts, etc. – and buy all the magazines you can find that cover that topic. You'll soon see that each has a slightly different way of handling its market. Some will aim at the beginner to the subject while others will be for the advanced worker; some magazines are produced purely for amateurs, others go straight for the professional; most magazines are published for the consumer, some deal only with the trade.

Take a good look at all these magazines and their various aspects and pick the one that appeals most to you. This is the one to concentrate on. Buy as many different copies of this one title as you can get hold of and study them in depth. This will be your chosen market and this is the magazine whose style you will have to learn.

Look first at the contents page. Invariably, you will find a list there of the various editorial staff members employed by the magazine. If the staff list is a long one, it's a fair bet that much of the work will be carried out in the office. If the list is short, it's more likely that the office staff will act only as a production unit and so they will be in greater need of freelance work.

Try to look beyond the world of the consumer magazines you see everyday in the local newsagent. A picture like this might sell to a specialist publication in the farming trade, never seen by the average magazine buyer.

Now start looking at the actual contents. Remember the point about the amount of colour magazines publish as opposed to black and white and examine your chosen market to see which predominates. Go from there to picture categories, and work out which of the five covered a few pages back the published pictures fall into.

Having ascertained the sort of pictures they use, you must now progress to discovering how much opportunity the market offers to you as a freelance. Most magazines publish bylines – the names of the writers and photographers who supplied the words and pictures – so compare these with those names on the contents page. This will tell you which parts of the magazine are regularly contributed by staff people and which come from freelances. The staff contributions are the items that you *won't* be able to supply. When you find names that are not obviously staff, check across two or three other issues of the magazine to find out if they are regular contributors. While there is every chance that, as a freelance, you could become a regular contributor, it is equally true that, in the first instance, you won't sell the sort of work that is being supplied by the current regulars.

Much of this philosophy applies more to the illustrated article type of submission than to straight picture sales, but it is still worth analysing your market in this way to get a really in-depth feel for the magazine concerned.

If the pictures in an article are supplied by the writer of that article, they will probably have no written information with them other than the caption. If, on the other hand, the pictures have been supplied by a separate photographer, or from the file, they will usually have a byline on the end of the caption. Check that to see if they use a lot of file pictures with other people's work, and check the bylines against other names in the magazine, both on articles and on the staff list. If the name appears nowhere else, it's a pretty safe bet that the picture was supplied for file use by an outside contributor like yourself.

Although few magazines actually employ staff photographers, some do have regular freelance photographers who cover different areas of the country for news reports and features, so once again, ignore the type of pictures that are obviously contributed by these people.

Look at covers in association with the contents of the magazine. Some publications use pictures on the cover that always have a direct bearing on one of the features inside. Others use more general pictures that have a connection with the overall subject of the magazine, but have little association with that month's editorial contents.

Having skated around the surface of your chosen magazine's requirements, you now begin to dig deeper to get a better idea about the publication's individual style and how that is applied to their picture needs.

If you are in the market for selling girl pictures, analyse the way the magazine feels about sex. Are the girls used only as a dressing to pictures of other objects like cars or motorbikes, or are they used more for their own sakes, decorating pages as fillers with little or no connection with the editorial feature on that page? Are the girls sexy or do they have a more homely image? How far do they go as far as dress is concerned? Does the magazine ever use topless pictures? Does it use nothing *but* topless pictures?

How many illustrations does each article use? If you are supplying pictures with words, send a few more than you see published with similar articles, but don't send *too* many. What about the actual approach to the subjects of the pictures? Is it a conventional approach or is it a little more off-beat? Some magazines like their pictures straight, others like an unusual angle on some or even all of them. Make sure you know which type your magazine uses.

You should also try to work out what type of person reads the magazine. The readership will be strongly reflected in the type of articles they run, so read these and work out what sort of people are buying the magazine. Is the readership predominently male or female, or are the articles aimed at an overall mix? What *class* of

person reads the magazine? Whether you approve or not, it is indisputable that this country is divided into working class, middle class and upper class; and for a magazine to survive it must know what class it is aiming at. That, in turn, can affect the sort of contributions it buys.

How old is the average reader? The magazine will know the age group at which it aims itself and that will show in its editorial. Is it written trendily with lots of slang and modern expressions, or is it more straight-laced? That too can affect the type of pictures it buys as much as the style of the words.

Look at the advertisement pages as well as the editorial pages. Advertisers, in many ways, are very much like freelances. They need to know the sort of market their advertisements are going to and, like you, they will tailor their style to the readership. As such, the advertisements can tell you a lot about the type of people who read the magazine. If the advertisements – and the general editorial, for that matter – are written is simple, easy-to-understand terms, it's because the readers are the type who need such simplification. By the same token, they will be more interested in straight, easy-to-understand pictures. If the advertisements and the editorial are written in a more sophisticated style, then the magazine might use more subtle pictures.

Looking at a magazine in as much detail as this might seem, at first, to be taking things to almost ridiculous lengths. Talk to any successful freelance, however, and you'll be told that it's never possible to know too much about your market. You *can* sell pictures to a magazine without going into this depth of analysis, but the more you know about your market the more chance you'll have of selling to it.

Let's turn now to some of those different types of magazine to see how all this theory works in practice and to see, in fairly general terms, who is buying what.

County magazines

Most counties in Britain have their own magazine that deals with interesting events, features of historical interest or any topic that relates to the particular county. The fees they pay aren't as high as some of the national magazines, but they do make a very good market for the freelance who is looking for a small but fairly steady income.

Children are good sellers to many markets, but generally they need to be involved in some activity. The straightforward family snapshot of a son or daughter rarely sells.

The majority of county magazines use a colour cover with only black and white inside. A few have a small use of inside colour as well. So the colour photographer is restricted to cover pictures, which usually depict some photogenic area of the county, sometimes linked to an editorial feature inside, but more often than not, used merely for its own sake. Most of the editors prefer a minimum size of 6 × 6 cm for these submissions. This is one cover market that does not rely on people for impact, although it's still a good idea to include some human interest in your landscapes when

submitting to a county magazine, to give the picture a sense of scale and sometimes aid the composition.

Inside, the photographer specialising in people will find a market for pictures of local craftsmen, people perhaps with unusual occupations or anyone else who has an interesting connection with some county activity.

General interest magazines

In this age of specialisation, the true general interest magazine is very much a thing of the past. Nevertheless, there are a very few still around, who still sell a worthwhile amount by bringing their readers news and views on anything and everything. Usually, however, there is a slightly off-beat slant to the subjects they cover.

This market usually looks towards girls for the cover, but the subjects will have an angle. Either they will be famous, or they will have a story to tell. Either way, they will be glamorous. Inside, a little colour might be used, but the best market will be for black and white. Again, girl pictures will be of interest, and here they don't have to be famous. Neither do the pictures have to conform to the basic idea of a glamour shot, as long as the girl is young, attractive and has some sort of story to tell.

People in unusual occupations or with strange hobbies will also find a place in this market. In fact anyone who has anything of genuine interest about themselves or their circumstances will find a potential sale in this type of magazine.

Women's magazines

Here we have the single largest sector of the UK magazine market, covering many different aspects of a woman's life from mother and baby magazines to hairdressing magazines; from romance to liberation. In the space available, there is no way to cover them all in any depth and, in any case, what you have learnt about market analysis will put you in good stead to find out what you stand the best chance of selling to the market. Nevertheless, here are a few tips.

In general, the glossier the magazine, the smaller the market for the general freelance. Some of the magazines that adorn the newsagents might look, at first sight, as if they are crying out for cover pictures of glamorous women or for pictures inside of perfectly made-up models, but in actual fact most of these are commissioned. The pictures, for instance, which might go with an article on make-up have undoubtedly been specially shot, while the cover could easily be tied in with a certain designer or hairdresser. Look at the credits inside that say who took the cover picture. If

A picture like this might serv several purposes. The angling magazine market would be interested in the actual subject, while the photo press would be more interested in the photographic technique behind the shot.

they include words like *dress by* . . . or *hair by* . . . it's a fair bet that the picture was specially taken for the magazine.

Come a little further down the market, however, and you begin to find magazines that use general pictures of pretty girls on their covers, and this is where you might more easily fit in.

Inside, there is scope for pictures, especially if accompanied by an article on interesting women or on interesting projects with which women have been involved. Some magazines specialise in the type of feature that, in effect, says 'you'll be surprised a woman can do this', so there is scope there for pictures of women doing unfeminine

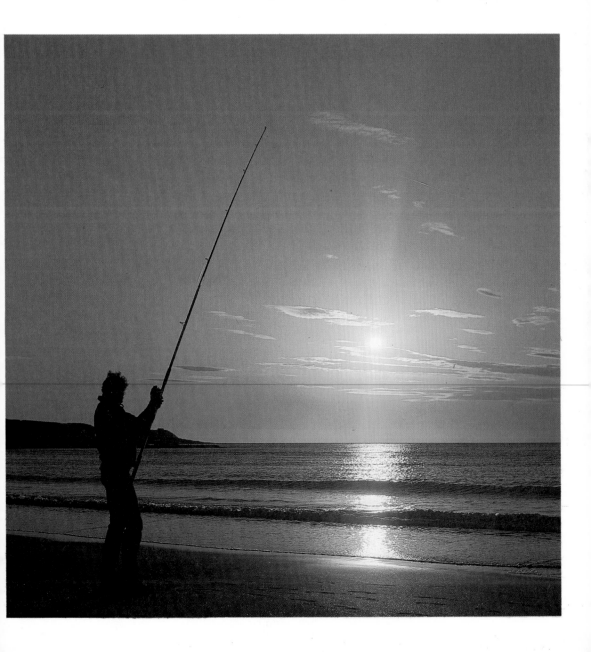

things such as stripping down a motor bike, driving a fire engine, climbing mountains, etc.

Another type of women's magazine is the one aimed specifically at mothers. This gives scope for baby pictures or young children pictures, but analyse your market carefully if you choose one of these. The magazines are very particular about what age of child they deal with, so make sure your pictures fit the requirements that your analysis indicates to be the right one.

One market that is often overlooked in the women's press, is the romantic fiction magazine. Strange as it might at first seem, this can be a very lucrative one for the freelance photographer. Analyse one of these magazines and you'll find it mainly consists of short stories with romantic interest, each story accompanied by a picture to illustrate its theme. When you come to look at the pictures, you'll find they always depict a situation. A girl sitting in her bedroom reading a letter, reacting to what someone else is saying to her, packing her bags, running for her life, walking out the front door, looking shocked, looking miserable, looking happy . . . the list goes on and on. Each of the pictures illustrates something about the story. The subjects of the pictures are not, as is often supposed by the readers, the actual heroines of the stories. They are models, amateur and professional, photographed by freelance photographers, full-time and part-time. Occasionally, if the story warrants it, they will be specially shot; most of the time, however, they are lifted from extensive files that show all manner of different types of girl, displaying all kinds of emotion. Those are the pictures that you can supply. Analyse the market and you'll see exactly what each magazine needs for its particular range of stories.

Hobby magazines

Everyone has a hobby and every hobby has a magazine, and in this we have a very good market for the freelance. Many hobby magazines are put together by a very small editorial staff, and it's not uncommon in this field to find a magazine that is totally produced by one man or woman. This is especially true in the modelling side of hobby publications – magazines that deal with subjects like model cars, model boats or model aircraft.

Look at one of these magazines and you'll find mostly pictures that are very obviously taken by the hobbyists themselves, rather than by actual freelance photographers. Give the editor a more professional approach than he gets from his usual set of contributors and you'll score every time. Find someone with an unusual hobby or who has a new approach to a traditional one, photograph him in action and you'll have the basis for the sort of contribution they need.

Covers in this market are invariably linked with a feature inside that particular issue, and although they are usually in colour, the editorial content of the magazine is more often restricted to black and white. The ideal package for this type of market, then, is a short article, some mono prints to illustrate it and a colour transparency to offer as possible cover material.

Photographic magazines

Perhaps the hobby magazine that will appeal more than any other to the freelance photographer is the one concerned with his own hobby or profession. Photographic magazines fall largely into three categories: the picture magazines, which deal mainly with portfolios of prominent or interesting new photographers; the equipment magazines that concern themselves principally with hardware, how to choose it and what's on the current market; and technique magazines that handle mostly 'how to do it' articles.

Of these, it might seem that the picture magazine is the most obvious target for the potential freelance. It isn't. First of all, picture magazines are thin on the ground, making them very selective about what they buy. Secondly, they tend to look more for arty pictures than the type which the average freelance handles. Of course, if you think you really do have an interesting portfolio of pictures that they might be interested in, then by all means give it a try. Such portfolios can be in colour or mono and they should normally have some kind of theme to them.

Perhaps the biggest market in the photographic press is the one that concerns itself with photographic technique. Submissions for this can take the form of articles or even just single pictures. If you're attempting an article, try to find a new angle on your subject; it's rare that you'll find an entirely new subject! If you are submitting pictures for the files, use as many comparisons as you can in your illustrations: shoot a model from the same viewpoint with different focal lengths of lens to show their different magnifications; dress someone in various colours and shoot them in mono with different filters to show their effect; or how about illustrating the effects of different types and directions of light on a face? Sets of pictures like these will often find a home in the file of a photographic magazine, and you could easily see them being used time and time again.

The third type of photographic magazine – the one that deals with equipment – might not seem at first sight to have much potential for the freelance. You won't, for instance, sell them pictures of cameras or test reports, because this is the sort of thing that is always handled by the staff or by a regular freelance. But even these magazines often need a file picture to explain the *use* of

some item of equipment, and they will always consider these if your submission suits their market.

Men's magazines

The most obvious subject for this market is glamour. All the men's magazines use sets of girl pictures, but just as with other markets, each magazine has its own quite individual style, which you'll be able to see as you analyse it. Some magazines go for the overtly sexy

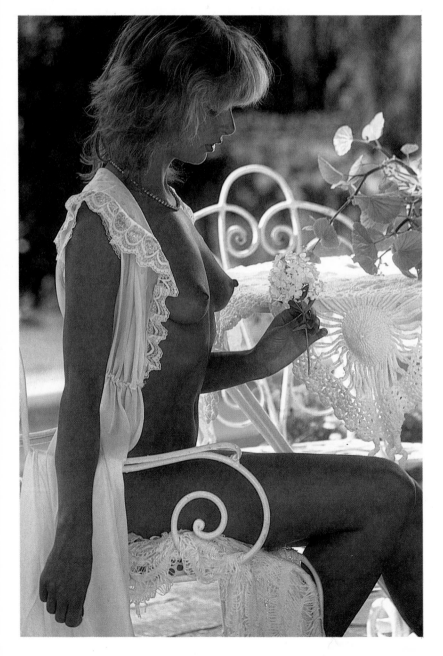

The dividing line between good glamour and bad taste is a thin one. If you want to make sales, you must take a professional attitude towards the choice of model and the way she is posed.

pictures, while others are more subtle; some use studio and outdoor locations, others like more natural locations such as a luxury flat or bedroom.

The glamour sets are all in colour and, in this, the men's magazines have one peculiarity. Almost without exception, they demand 35mm Kodachrome as the preferred, and sometimes only, emulsion for contributions.

Away from the glamour sets, men's magazines are also interested in male-dominated hobbies, which gives an opportunity to photograph men at work or play for this market.

Covers are always in colour, usually depict a girl from one of the sets inside the magazine, but often display a slightly different style to the inside pictures. Whereas those inside can be extremely explicit at times, those on the cover are usually a little more coy and, over the past few years, they have actually become more prudish in that direction. At the time of writing, very few of these magazines actually show a girl's nipples on their cover, even if inside they show just about everything there is to be seen!

Trade magazines

Walk into any newsagent and you'll see a magazine for just about every subject under the sun. In general, these are consumer magazines, so called because you, the consumer, are the person who buys them. There are, however, a great deal of magazines that you rarely, if ever, see in your local newsagent. These are the trade versions which, rather than deal with the various subjects as you use them, deal instead with the commercial side: imports and exports, selling the various products, displaying them, the problems of the manufacturer, distributor and shopkeeper. The magazines aren't as well seen, but for the freelance, most of them are every bit as lucrative as their consumer counterparts.

The problem, as far as the freelance is concerned, is that these magazines aren't as easy to get hold of as the consumer types, so they are more difficult to analyse. But it's worth bearing in mind that if you happen to photograph a tradesman for, perhaps, some other market such as a hobby publication, it's always worth asking if he subscribes to a trade magazine of any sort and if you can take a look at it. Doing that could easily double your freelance potential on many of the pictures you take.

Many trade magazines and their requirements are listed in *The Freelance Photographer's Market Handbook.*

House magazines

Most big organisations have their own magazine or newspaper.

Some are just simple, all-mono publications, others are as glossy and as colourful as a more conventional consumer or trade magazine.

The purpose of these publications is to promote the organisation to which it belongs and to bring employees news and features about other employees – their interests, their hobbies, their successes. Once again, then, if you are photographing someone who has an interesting story to tell, it's worth asking him or her who they work for and whether their company has a house magazine. If the subject you are shooting is of interest to the national magazine market, it's a fair bet that it will be of even more interest to the company who has a personal interest in the person involved.

Partworks

A partwork is a very specialist type of magazine that works like no other. It is sold in newsagent shops just like more conventional magazines, but unlike those, it is designed to sell only for a limited period. Its contents are planned in meticulous detail in much the way a book might be and the articles are organised to teach readers about specific subjects, starting with basics and taking them right through every aspect. The reader who buys a complete set will end up with the equivalent of an encyclopedia on everything that can be said about the subject.

These partworks are usually put together by a team of organisers who employ freelance writers to supply specific features, covering specific points to a specific style. The same organisers then buy in or commission the best pictures around to illustrate the features.

Subjects covered by partworks are many and varied – motoring, photography, knitting, gardening, anything and everything that interests the average member of the public. The partworks are usually designed to run for a couple of years and, at the moment when the first weekly instalment arrives on the bookstalls, it's a fair bet that the publishers haven't planned, in detail, much beyond the sixth. So that's your point to strike, right at the start, as soon as you see a new one arrive.

Buy one, analyse it, put together some ideas and contact the publishers, offering your services. In the first instance, they will undoubtedly want to see something on spec, but if you prove that you can deliver the goods, you could well find yourself with some regular, and very profitable, commissions at intervals over the next few years.

Covers

Cover pictures have been mentioned in passing over most of the

above magazine markets, but it's worth looking at them in a little more detail if you want to sell pictures for them. just like the contents of any magazine, these too can be analysed and, once you do that, you'll see how much difference there really is between what might look like two almost identical markets.

First of all, covers are usually in colour, and despite requirements inside the magazine, editors invariably prefer a larger format than 35mm. Medium formats like 6 × 4.5 cm, 6 × 6 cm and 6 × 7 cm are usually the most acceptable. The subjects of the covers are, of course, as varied as the contents of any individual magazine, but certain styles in the way the pictures are shot are universal to all markets.

Apart from the picture, a magazine cover can contain a lot of words. At the top, it houses the logo, which is the magazine's title; down one or both sides, it lists the coverlines, those brief and often pithy words that sum up the main contents of the issue; and elsewhere it features things like the price, the name of the publisher, the month of issue, further words qualifying the magazine's title and – to a growing extent these days – a bar code. All these things have to be taken into consideration when an editor chooses a suitable cover and, for your part, when you supply it.

Pictures are used on covers in two different ways. In the first, they are dropped into a panel, surrounded by a coloured background on which all the peripheral words, logo, etc. are detailed. For this type of cover, the picture should be composed in the conventional way, making maximum use of every part of the picture area.

The second type of cover is what is known in the publishing world as a 'bleed'. This means that the picture itself fills the whole cover, its edges 'bled' to the four sides of the paper, with the logo, coverlines, etc. projected over the picture. For this type of cover, the picture has to be chosen and, ideally, posed very carefully. For a start, there must be room at the top of the picture area for the magazine logo. Then there must be room for the coverlines which, on the vast majority of magazines, are positioned down the left hand side so that they can easily be read on a newsagent's shelf when the magazine is half-covered by another magazine, the way many newsagents arrange their stock.

A picture, then, that has been specifically shot with a certain magazine cover in mind might, on its own, look strangely off-balance, with the subject in the bottom right-hand corner and a lot of what appears to be wasted space above and to the side. Perhaps the best way of shooting this type of picture if you are working with cover use specifically in mind, is to shoot on a 6 × 6 cm square format with a good deal of space on each side and above the subject's head. This gives the editor a number of choices. It allows him to place his logo at the top, then crop the picture on the left or

right to fill the oblong format of the cover, while leaving space for coverlines on either or even both sides. It also allows him to reverse the picture should he desire, so that the subject is looking in a different direction, while still keeping the facility to put coverlines on whichever side best suits the title. It even allows him to crop the picture all the way down to the subject, filling the frame with a picture that is dropped into a panel, while still retaining the necessary quality that a similar exercise on 35mm might not have provided.

So when you choose your magazine and begin your analysis, don't start and end with the contents of the issue. Look too at the cover and, if you are aiming to provide a picture for it, make sure you comply with the necessary style.

Adding the words

Finally, in this chapter, let's look very briefly at something which, at first sight, might appear to have little to do with actual photography but which, once you have learnt a few techniques, could improve your selling potential to magazines one hundred per cent. We're talking about the art of adding words to your pictures, either in the form of captions or as a full-blown article. The task breaks down into two basic functions: gathering the facts and putting them down on paper.

We're not going to look here at the ins and outs of what *sort* of features or captions to write, because it can largely be assumed that by now you have learnt your market and you know what you want to write, and for which magazine you are going to write it. What we are going to look at, are a few ways and means to make the task of getting those words down on paper a little easier.

The first way of getting the facts is to interview the people you are photographing about their hobby, occupation, or whatever other aspect of their life you are seeking to illustrate. Interviews are nothing to be afraid of, they're just a matter of chatting slowly and confidently to your subjects, keeping them on the right track without wandering off into detail that doesn't concern the matter in hand, and making sure they tell you all you need to know.

It's often a good idea to think things through in advance, getting straight in your mind the sort of questions that need answers, even making a list of questions. If you make a list, don't be afraid to use it when you conduct the interview. It will give you something to fall back on when the conversation comes to a standstill. But don't be afraid to deviate from your list. If your subject's answer prompts another natural question that needs to be answered, don't be afraid to ask, just because you didn't put that question on the list in the first place. Don't be afraid either of showing your ignorance on a

subject. That's why you're asking the questions and your subject is being interviewed. If he or she says anything at all that you don't understand, ask for a fuller explanation. Because if *you* don't understand, your *readers* won't understand either.

What sort of questions do you ask? There are a whole lot that will naturally spring to mind as soon as you start thinking about the particular subject you are working on. But mostly, interviews revolve around the information gleaned from six basic words. Read

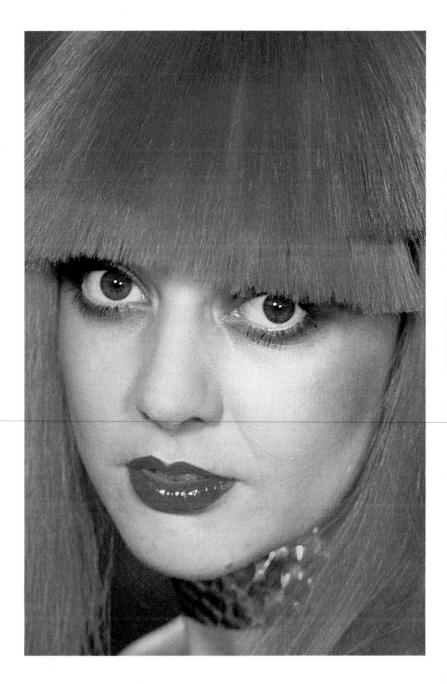

To work as a cover shot, a picture like this would need a magazine that used its cover pictures in panels within the covers, rather than bled to all four sides. Alternatively, the picture would make a good illustration for the photographic technique of portraiture in the photo press.

them now, commit them to memory and, whenever you interview someone, check them over in your mind to see if you have covered all six. Here are the words: *Who, what, where, when, how* and *why*.

Supposing, for instance, you are interviewing someone who has just made and flown an unusual, record-breaking model aircraft. Look at the way those six words would guide you towards getting the facts:

Who are you? From this, you get the subject's name, age, occupation, where he lives, the sort of person he is and his general background.

What are you doing? In reply, you'll get details of the model aircraft, what's so special about it, what records it has broken, what it might be doing in the future.

Where did you fly it? Pretty self-explanatory, this one. Your subject will give you details of location, etc. which might influence the place where you aim to sell your article.

When did you fly it? This is more important than you might think. If we're talking about record breaking and the event happened a year ago, you have a general feature piece for a magazine. If the record was a little more dramatic and it only happened this morning, then you could have an interesting news item.

How did you build the aircraft? Here we get the nitty-gritty that is going to appeal to the hobby market you might be aiming at, and which might produce some interesting general facts that the less dedicated reader could just as easily be interested in.

Why did you fly it? Everyone has reasons for wanting to take up a hobby or break a record. This question can produce some of the most fascinating information of all.

Looked at like that, you can see that with just a series of simple questions, based around those six words, you'd probably get enough information to make at least a 1,000 word article.

Asking the questions at an interview is the major part of the battle, but just as important is recording what the subject says. Always make sure you do that. Don't rely on your memory for the details you'll need later. Many journalists these days use one of the small, portable tape recorders on the market, but if you don't own one – or can't afford one – don't despair. A good, old-fashioned notebook and pencil are just as good. If you can write shorthand, you have a strong advantage, but even if you can't, you'll soon develop the knack of writing fast, abreviating certain words and just jotting down the salient points.

Incidentally, when you are writing things down like this, always check the spellings of names and any technical terms you're not sure of and write these down clearly in your notebook. If you're using a tape recorder, spell them out for the recording.

Once you have done all that, you are half-way towards producing a written article. The second step is to get it all down on paper. Again, this isn't nearly as difficult as most people seem to think. There's nothing mysterious about writing. All you have to do is write down the facts, clearly and concisely, in much the way you would tell them to a friend.

If the extent of the words you are writing mean no more than a picture caption, the style to adopt should be short, sharp and to the point, just covering the relevant facts without any elaborations. Even if your writing style isn't up to scratch, the magazine staff can always rewrite captions, providing you have furnished them with the relevant facts.

When it comes to writing a feature, however, you need a little more skill. You need to start with an intro. That's a short paragraph that introduces you to what the feature is all about, while leading your readers into the main body of the article and, most important, giving them a reason for wanting to keep reading. The best intros are informative without giving away too many facts, fun, contentious or provocative. They need to make the reader think, '*this sounds interesting, I must read more.*'

After the intro, comes the main body of the feature. This is where you set out all those facts that you obtained from your who, what, where, when, how and why questions. Put them down in short sentences. Never use a long, elaborate construction of words when you can use two or three shorter combinations. Write and rewrite the words until they sound their best. Read them out loud to double check that they make sense.

Then finish your article with another short, sharp paragraph that wraps everything up neatly and leaves your readers feeling satisfied.

If you wrote your article in longhand, have it typed. If you typed it to start with and it's now in a mess because of all the alterations and amendments you've added as you went along, then retype it. Either way, you should end up with a manuscript that is neatly typed, double spaced on one side only of a series of A4 sheets of paper, with a margin down each side of at least an inch.

When it comes to giving your feature a title, don't be too fussy or try to be clever. just give it a straight, no-nonsense, descriptive type of title, because at the end of the day, the magazine editor will probably change it to fit the style of his publication.

Type the title, together with the article's number of words, your name, address and daytime telephone number on a separate piece of paper and attach this to the front of your manuscript. Write picture captions on a separate sheet of paper, each one identified by a number which is duplicated on the back of each relevant print or on the mounts of slides. Attach the captions to the back of your manuscript.

In the space available here, this is, by necessity, only the briefest description of how to write an illustrated article. But just going along with these few brief and simple rules will give you the basis for producing acceptable features.

Any editor will tell you that the freelance who can both write and take decent pictures is worth his or her weight in gold. If you want to substantially increase your selling potential in the magazine market, you owe it to yourself to take the next step and start writing.

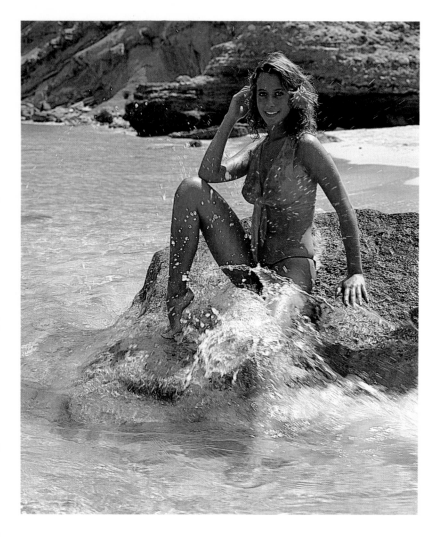

Glamour is an obvious target for the photographer who shoots people and who wants to break into the calendar market.

Other Publishers

Magazines and newspapers are the most obvious outlets for the freelance in search of publication. The market they cover is vast and can be very profitable. But there are other types of publisher who specialise in very different types of publication. Greetings cards, calendars, posters, books and travel brochures all offer different outlets for the freelance photographer and all, in varying degrees, take people pictures.

Greetings Cards

This is perhaps the *least* profitable outlet for people pictures. Although the greetings card market is vast, its requirements are mostly for subjects like landscapes, country cottages, flowers, vintage cars and the like. Perhaps the only real outlet for people pictures in this market is with those subjects that concern sporting activities – a subject that a fair percentage of greetings card publishers list among their needs. Even landscape pictures that use people as foreground interest are often rejected by greetings card publishers, mainly because hairstyles and clothing date the scene and, in buying a picture for use on a card, the publisher is looking for a subject that he can use over and over for many years to come.

If, however, your subject is sport, or you do find one of the other small outlets for people pictures among greetings card publishers, there are a few pointers worth knowing. The first concerns format. The market is only for colour and, needless to say, that means transparencies, *never* prints. But the biggest criterion to bear in mind is the size of the transparency. The greetings card market has always been notorious in the past for its rejection of 35mm. True, that a few publishers these days are beginning to bend a little, considering 35mm if the quality is absolutely first class, but the majority insist on a *minimum* size of 6 × 6 cm, many demanding nothing smaller than 5 × 4 inch originals and a few still requiring 10 × 8 inch originals.

Even those publishers that do take 35mm, will still show a preference for larger formats and so, if you really mean to succeed in this market, it is advisable to invest in a medium or large format camera of some kind. When you consider the fact that the average

greetings card is quite small, compared to even the full-page size of a magazine, this opposition to 35mm night seem unreasonable and perhaps even unbelievable. But facts are facts. That's what the market demands and, if you mean to sell to it, you must comply with their requirements.

More and more greetings card publishers these days are using artwork, rather than pure photography, in their card designs, but those that do use original transparencies tend to adopt two basic approaches, each of which can affect the way you take the picture in the first place. Both approaches favour vertical formats, so if you are using a square format camera, you should compose your picture with this thought in mind; if you use a larger, oblong format, then you should turn the camera or the film back to allow an upright, rather than horizontal, picture. The first of the two styles to bear in mind bleeds the picture to the four sides of the card, so that space must be left in the composition for wording. In this respect, composing the picture is not unlike taking a cover picture for a mgazine, leaving space for the logo and coverlines. The second style – which can also be compared to a magazine cover – drops the picture into an artwork frame on which the wording is added. In that instance, the subject of the picture you supply should fill the frame on all four sides. When shooting with this market in mind, then, it's not a bad idea to shoot two versions of each picture: one with and one without space for the card's message.

Calendars

In many ways, the calendar market is a lot like the greetings card market, in that the publishers' requirements are, in many cases, similar, both in subject matter and in the format in which it is presented. Once again, the market is exclusively for colour transparencies, and again the minimum size is important. Strange as it may seem, however, calendar publishers aren't quite as strict about minimum sizes as greetings card publishers. While most call for transparencies of at least medium format, very few request minimums of 5 × 4 inch – a demand that is quite frequent in the greetings card market. Some are even quite serious about accepting 35mm, providing it is of the very best quality, but in general, if you are serious about the calendar market, you should invest in a medium format rollfilm camera.

Like the greetings card market, this one is very much in favour of landscapes, cottages and similar subjects, but unlike the greetings card market, the calendar companies do have one very big requirement for a certain type of people picture in the shape of glamour. There are two ways to use glamour pictures if you have the calendar market in mind. The first is to simply submit

One very strong section of the calendar market is for a very specific type of people picture.

selections on spec or personally by appointment to appropriate publishers in the same way as you might submit landscapes and the like. The addresses of the publishers can usually be found on the calendars themselves, so you can check them out while you analyse the style of pictures they use. Alternatively, if you are a member of the Bureau of Freelance Photographers, you'll find most of the addresses plus their various requirements in the market surveys that the Bureau regularly issues on this, among many other, subjects. Addresses and requirements are also listed in *The Freelance Photographer's Market Handbook*. The second way to use glamour in this market is by setting out to produce your own calendar.

This idea might sound a little ambitious to start with, but in the long run, it can be a lot more lucrative and much more successful than the more usual way of merely supplying your pictures to a publisher. And, when you come right down to it, it's a lot easier than you might imagine.

First you need a client. For the average, unknown, freelance it goes without saying that you should avoid the big names like Pirelli and Unipart who already have their yearly requirements met by

the big names in photography, shooting to a concept usually dreamt up by their advertising agencies. The people you are looking for should be small-to-medium size companies in industries like car parts, engineering, clothing, etc. – the sort of people who have a lot of clients of their own to whom they might want to send a calendar.

Make your contact with the managing director – or the first minion beneath him who is prepared to talk with you. Discuss your idea in general and, having seen the company's product, suggest ways in which it might be included in the pictures. Find out how much they are prepared to spend, then go away and get a dummy together. At this point, it is a good idea to link up with a freelance artist who can design you a couple of concepts. Depending on funds available, you can design a calendar with twelve pictures – one for each month, or as few as four pictures – one between each three-month quarter. Show your design to a printer and get a quote for the job, take into account the modelling fees you'll have to pay, travel expenses, hotel bills, etc., add on your own mark-up and take the quote back to the client.

In order to reduce costs a little – and also to make more money for yourself into the bargain – you might approach several clients at once, getting a few different concepts together, all of which can be shot with a couple of models in the same location and at the same time.

Working to a tight schedule like this, it is imperative to use professional models, and it is advisable to have the basic ideas for the different pictures worked out roughly in advance. Work with your artist in this respect: you'll find his input can be as creative as your own. When it comes to a location, it is rarely a good idea to shoot in England because of the unreliable weather. Neither is it necessary, however, to go for one of the expensively exotic locations used by the likes of Lichfield and Bailey for their calendars. Instead, look towards an inexpensive package tour. Even places like Majorca can give you the kind of backgrounds you require, once you get away from the tourist areas.

Working to a tight schedule, with a small team of professionals, it is possible to cover all you'll need in a week, although if you can afford the modelling fees for a few more days, it could mean all the difference between a good and bad result. It isn't a good idea to work alone on an assignment like this, better to take an assistant, probably the artist with whom you have conceived the project to begin with. On arrival at the location, allow a couple of days before you start shooting to travel around, looking for suitable locations that will fit in with your initial ideas. During this time, the models can remain at the hotel, tanning up and ready for action.

When you start to shoot, work during the morning until about

ten o'clock, then knock off during the middle of the day and shoot again during the later afternoon and early evening. These are the times when the light will be best for this type of photography.

Back home, show the results to your clients, and work with your artist and printer towards producing the final results in the way they were originally planned. At the end of the day, you should have enough pictures, not only for your planned calendars, but also to send off to independent calendar publishers on spec. And you should have a good set of pictures for possible magazine articles. You might even consider putting together an article for the photographic press on how to shoot a glamour calendar on a shoe-string. Submit it in October, when the monthly magazines will be starting to think about January issues, and you could have a good chance of a sale.

The initial idea of planning a shoot like this might seem a little daunting at first, not to mention expensive. But once you begin to look at the returns, you'll soon discover that such a project can make you a lot of cash.

Posters

The poster market is one that has grown tremendously since its inception. Poster companies take all sorts of subjects, including people in various guises. Glamour can sell to this market, as can pictures of famous personalities. One of the biggest potentials in the poster market is for the humorous subject – something that can easily involve people. One of the biggest sellers ever in this field is a poster showing a girl tennis player, walking away from the camera, towards the net on a tennis court, casually lifting her skirt to scratch her bare behind. Anyone who has seen the poster will know that it is an extremely well executed piece of work. It is cheeky (in more ways than one!) and funny, without being in any way offensive. Its charm is that it appears to be taken candidly, even though it was obviously posed. Yet it is the type of pose that anyone could have set up, given the idea in the first place. Come up with a similar idea and you stand a good chance of selling to the poster market.

Strange as it might seem, considering the size of the end product, the poster market isn't as fussy about large format originals as either the calendar or the greetings card market. Naturally, with the product in mind, the larger the format of the original transparency, the better its chance of success, but many poster companies settle for medium formats from 120 rollfilm cameras and some will even take 35mm, providing the quality is absolutely first class – pin-sharp focus and perfect exposure being of para-mount importance.

A good all-round shot that demonstrates photo technique for the photo press and photo book market, while also making an illustration for the specialist motor cycle publications.

Book Illustrations

Book publishers are a lot like magazines. They have different books, covering different, very specific, subjects, and they need pictures to help illustrate them. By the same token, authors are like magazine contributors. Sometimes they deliver a complete package of words and pictures, at other times they collaborate with a photographer. The publisher, in turn, can accept every picture the author delivers, using *only* these pictures; he might supplement the author's pictures from another source; or he might commission the author to supply just the words, offering the picture commission on the same book to a separate photographer. Likewise, he might buy in pictures from many different sources. Sometimes a book publisher will *start* with the pictures, building up a complete design and feeling for the book

without any words at all. Then, almost as a last resort, he will employ a writer to supply exactly the type of words he needs to fit his idea. All these different ways of working provide an outlet for you as a freelance photographer.

A good place to start is by submitting to a publisher's files. Many publishers – especially those that publish photographic books – keep a picture file in just the way a magazine does. Like a magazine, the publisher will be looking for certain categories of picture to fit the subjects of different books. People pictures will always be to the fore in these circumstances, simply because of the human interest factor. People get involved with all sorts of subjects. From wine-making to car maintenance, there's an outlet for people pictures: people making wine, people working on their cars.

Book publishers, like their magazine counterparts, all have their own specialist interests. In order to sell to them, you need first to analyse your market in just the way you would with a magazine. Find a range of books in your local bookshop that deals with interests you feel you could illustrate. You'll find the name and address of the publisher, usually, on one of the early left-hand pages in the book, together with various cataloguing data. Make contact by letter or telephone in just the way you would with a magazine and tell them what you have to offer, inquiring if they would be interested in file material. The market here is chiefly for black and white, and the man or woman to contact is the commissioning editor, handling the specific subject you have in mind.

The next step on from here is to try getting your own book published. To the uninitiated, that might seem like a formidable task, but once you know the tricks of the trade, you'll find it isn't as difficult as it might seem. Book publishers, just like magazine editors, are always on the look-out for new talent. Without it, they wouldn't survive. That's where you come in.

A book is, in many ways, like an extra-long magazine article. It has a theme and a market. That applies to written text books that use pictures to illustrate their theme, but it equally applies to picture books. Perhaps the most obvious picture book subject for the photographer who specialises in people is glamour, although if you consider yourself to be a freelance writer as well as a photographer, then the field is limitless as you use people pictures to illustrate various aspects of your chosen subject. Whatever your approach, you need to think of an original angle. Everything has been done before, but it will undoubtedly be done again. Even glamour books which, at first sight, seem to offer little more than page after page of naked ladies will, on closer examination, be found to have themes and approaches which are unique to each particular book. The angle might be no more than the fact that the pictures are the work of one well-known photographer, but for the

rest of us, lesser-known photographers, the angle will more likely be concerned with a specific *type* of picture.

Once you have your angle sorted out, then you should put together a sizable portfolio of your work, together with a few words about the pictures, why they are different to those of other photographers and why you feel a book is needed on this subject. When you do this, look very carefully at your justifications. Don't try to justify reasons why *your* pictures would make a book in themselves, but rather set out to justify why there is a real need for a particular type of book, and then show how your pictures will fit in with this market. The line between those two arguments is a fine one, but it is a very important one. The freelance who aims to get his pictures in magazines must first find a market and then shoot pictures to fulfil that market. The freelance who attempts to get a book published must take that line of thinking one step further. Much of the time he must think more in terms of *creating* a market first, then filling it with his pictures.

When you come to approach a publisher, go for one that has a proven track record in the type of subject you have in mind. Analyse books in your local bookshop to find the best publisher for you. Don't approach publishers who never deal with your subject: taking a book on glamour to a publisher who only prints fiction, for instance, is a complete waste of time. But don't be afraid to approach a publisher who already deals with *allied* subjects. One who has never published a photographic book, for example, but who has a proven success in, say, the video field, might easily be ready to branch out into the world of photography if someone like you comes along with the right proposal. In this respect, book publishers are unlike magazine publishers.

Travel Brochures

This is one market that is exclusively for colour and, like so many other colour outlets, the larger the format the better. The market here is designed specifically to attract customers to take a holiday with a particular travel company. So, as obvious as it might sound at first, it is absolutely necessary for your pictures to show their subject in the best light. This is a field that is dominated by sunshine and blue skies. Pictures shot in dull, overcast conditions will *never* sell to a travel brochure.

The travel brochure market is one that is very easy to analyse, simply because any travel agent will be pleased to give away piles of brochures if he is under the impression you are going to make a booking! Look through their pages and you will find the illustrations fall into three strong categories: hotels, resorts and people enjoying themselves. The last category is obviously yours.

Picture pretty girls on the beach, happy couples sharing a drink at some tropical poolside, families of attractive parents and children frolicking in the waves. Standard, soft-core glamour, shot in bright sunlight on a beach or in the sea will always stand you in good stead with this market, used to dress the pages inside the brochure or even to make a cover for it. If you shoot with this in mind, try to get anonymous pictures that don't identify the particular resort. That way, you stand a chance of selling the picture to any one of several different companies, each of whom specialises in different countries. Other pictures in the brochure will identify the locations; your place as a photographer of people is to provide the human interest and, in that respect, a set of pictures that were actually taken on a package tour to Spain could easily end up being used to illustrate locations all over the world.

You'll find the addresses of the various travel companies in their brochures. Give them a ring before you submit, asking to speak to the person in charge of picture buying for the brochures. If it's a large company you'll probably find yourself transferred to the company's public relations or advertising agency, where you'll have to speak to the picture buyer who handles that particular travel company's account.

People feature prominently in most holiday brochures. Get the style right and you stand to make good sales in this area.

Another method of selling pictures to the travel industry is through a picture library or agent, but that's another story and one we'll be looking at in the next chapter.

Picture Agencies

Right at the start, let's clear up one very popular misconception about agencies. They are not in business to sell your rejections. It is a sad fact that many photographers seem to look upon agencies as a last resort, somewhere to send pictures that they personally have failed to sell elsewhere. That's the wrong attitude entirely. It's true that an agency might find a sale for pictures that you might not otherwise have been able to sell for yourself. But they will never find a market for *bad* pictures. When you start to deal with an agency, then, try to think in much the same way as you would for other markets. Make sure your pictures are up to scratch technically and make sure they match up to their markets.

Now wait a minute. How can you match pictures to markets when they are being used by agencies to sell to often widely-different markets? Very simple. In this instance, the agency itself is the market. There are many different agencies and each specialises in a different type of picture. So, once again, a little market research is needed to prevent wasted time, submitting, say, sports pictures to an agency that deals only with wildlife. Also, even though you are dealing with your market through an agency, it is still a good idea to think strongly in terms of some specific market when you take the pictures. Sending a set of pictures to an agency, telling them they are aimed, for instance, at the calendar market is a lot better than merely sending a set of unrelated shots with a kind of *here's some pictures sell them where you like* attitude.

First of all, then, you need to find your agency. Many are based in London and you'll find them in the London Yellow Pages. Some advertise in the photographic press and there is always news of agency requirements in the monthly newsletter issued confidentially to members of the Bureau of Freelance Photographers. If you are a member of the BFP, they have a handy little booklet available called *The BFP Guide To Picture Agencies and How To Use Them*. It does exactly what its title suggests. You'll also find agency details listed in *The Freelance Photographer's Market Handbook*.

Before you start to deal with a picture agent, it's as well to learn a little about how they work. A photo agency's whole reason for being is to stock up with good, saleable pictures, then pass them on to suitable clients on behalf of the photographer. Nothing more. They are not there to teach you about ways of taking better

Picture agencies deal
mostly in colour. Glamour
is a good seller here.

pictures, so if the shots you send them are not suitable, they'll probably be returned with little more than a polite rejection slip. They have no time for any further indulgence with photographers who clearly will be of little use to them. On the other hand, if an agency sees that you have the potential to produce the type of work they need, but that you are not handling things in the right way, then they may well offer a little encouragement; you could find yourself invited in to discuss your work and how it might be steered towards their requirements.

Photo agencies deal with all kinds of different markets, though primarily, most are concerned with magazine and book publishers, advertising agencies, tour operators, greetings card and calendar publishers, as well as AV companies and even television companies in search of specific subjects in the form of still photographs.

Your first step, then, using the reference points already discussed, is to find an agent who handles the type of photography you are most interested in. Since we are talking essentially about people pictures, the options are pretty wide. The first option is for the type of shot that depicts people in a straightforward manner. Sport comes immediately to mind, as does glamour. But agencies are interested in much more than this. Some go for pictures of people depicted in humorous ways; others look for pictures which show certain specific types of human behaviour – how people react to certain situations.

There is a market among clients such as advertising agencies and AV producers for normal, everyday life: pictures that show people involved in eating, drinking, playing, watching television, etc. and this is one area in which such clients nearly always turn to photo agencies rather than to individual photographers. Shooting this type of picture seems, on the surface, to be pretty easy and the ideal way of making a start with agencies, but it might not be as simple as you might think. If you decide to try it for yourself, don't confuse 'ordinary' subjects with slip-shod technique. You can't just snap away with direct flash as your family sits around the dinner table or TV. Pictures of this type need to be set up specifically for the camera, the subjects posed in the best possible way and a careful watch kept on the rest of the room. There's little worse than a domestic environment to produce messy, distracting backgrounds behind otherwise perfect subjects.

People involved in industry and crafts can also be sellers for agencies, as can others shown enjoying the amenities in tourist spots. Education, entertainment, fashion and health subjects can all include people – and all appeal to agencies. Not to mention personalities from the world of sport, politics and show business. Capture a famous person in an unusual situation and you'll find agencies ready and willing to take your work.

So, having decided on the type of people picture you have to offer and which agency you are going to offer your pictures to, you need to make your initial approach. just as with most other forms of freelancing, the personal way is the best, but don't turn up on an agency's doorstep unannounced. Telephone first and double-check their requirements. If it sounds like they would be interested in your type of photography, tell them a few brief details about yourself – the type of work you specialise in, any sales you might have made in the past – and ask if they would be interested in seeing you and your work.

Assuming the answer is yes, get yourself prepared for the meeting well in advance. First of all, organise a sizeable number of pictures. There is little point in approaching an agency with just one or two shots. Most have a minimum initial submission, which will probably be of around 300 slides, with the proven potential to keep

A straightforward everyday scene like this can make good sales with picture agencies.

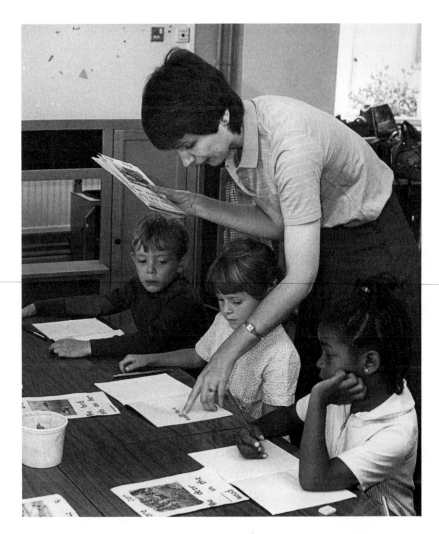

supplying at a rate of perhaps 100 pictures a month. So make sure you have enough pictures for the interview. And don't pad your submission out with mediocre pictures just to make up the number. If you are not confident in all the pictures you are going to show, then you are not ready yet to deal with an agency.

The biggest market here is for colour transparencies. Some agencies take black and white prints, but it goes without saying that none will consider colour prints. Assuming you are submitting slides, arrange them in a neat, easy-to-view manner, preferably in plastic filing sheets that take a good number of slides, together in a single sheet. Do not turn up at the agency with a lot of plastic slide boxes. To do so would be totally unprofessional and give them the wrong idea about your work right from the start, even if the pictures themselves are actually very good.

Many agencies today deal with 35mm slides, but even those that make many sales from the format would probably prefer to see medium or larger format originals whenever possible. So, just as with any other colour market, don't show 35mm if you have another option. And, if you are confined to 35mm, then check before you attend to make sure that they actually handle the format.

So, you've chosen your subject, you've found your agency, been along for an interview and they've agreed to handle your work – what happens next? Very often, absolutely nothing. Now is the time to exercise your patience, because an acceptance onto the agency's files is not a fast guarantee of sales. On the other hand, you can rest safe in the knowledge that you wouldn't have been accepted in the first place if the agency didn't consider your work was saleable.

One of the questions often asked by photographers who are inexperienced in working with a photo agency, can best be summed up like this: 'What's to stop them selling my work over and over to markets I might never see, pocketing the fees and not paying me my share? And even if they do pay me, how do I know that I am getting the correct percentage when I have no real way of checking up on how much they were paid in the first place?'

There are no real answers to questions like that. The fact is that you *don't* have any real way of keeping check on such matters, you just have to trust them. But if you stick with reputable agencies, there is no reason why you should have any trouble. After all, look at it from their side. Supposing they do cheat you and you find out? You only have to spread the word and they would be out of business. It just isn't worth their while. Most of the top agencies are members of the British Association of Picture Libraries and Agencies and while non-membership does not imply anything untoward, actual membership is a good sign of reputability.

Once the agency has accepted your pictures for their files, they have a lot of work of their own to begin. There is a good chance that they will remount all your slides in their own mounts. They must catalogue your work and file it under their own categories in a way that is easy for both the agency staff and their clients to find and see what's available on each of their specialist subjects. Many of the sales they make on your behalf will be to recognised clients who make appointments to view the files and pick out pictures which fit with their own particular briefs. At other times, the agency will chase up clients on your behalf, offering your work to markets they think will be most interested. This gives a two-fold advantage to you. On the one hand, the agency will know about and find markets that you might never have considered or even heard of before; on the other hand, clients that would be out of reach to you as an individual will come to the agency in the knowledge that any pictures they choose will be worthwhile for their own projects.

All of this might happen, however, over quite a wide space of time, so agencies should never be thought of as fast, one-off ways of earning money. Obviously, the more pictures you have in an agency, and the longer you leave them there, the better your chances. If you have been accepted, there's a fair chance that they have taken a few hundred of your pictures as a first submission. There's also a good chance that they have asked you to leave them on file with them for a minimum period – usually around five years. To increase your chances of success now, it is in your interest to keep the agency topped up, supplying them with regular batches of pictures every month. Don't worry about being too persistent. If your pictures are the type they need, they'll take all they can get; if they don't come up to requirements and they feel you are wasting their time, they'll soon tell you.

The way an agency sells your pictures isn't the way a butcher sells meat over a counter. First of all, they don't sell the actual picture, only the right to use it once, in a particular and specified way. The client will specify the sort of picture or pictures he is looking for, then spend time searching through the files. He will rarely pick just one picture, but will ask for a selection that he can take away with him for further consideration. The agency will book these pictures out to him for a brief period – usually a few weeks. During that time, the client considers his selection and returns the pictures he does not wish to use. He even has the right to return them all if he so decides. There is little risk of your pictures getting lost this way, because the agency will automatically chase the client when the time is up and, if he fails to return the pictures or to give a reasonable excuse for keeping them longer, a holding fee will be charged per slide, per week. The terms that apply to this will be set out to the client in writing when he takes the pictures away, so he

has no excuse for saying he didn't know about the holding fee, and the fee itself will be sufficiently high to deter him from keeping the pictures a day longer than is necessary.

When the picture has been chosen, the rights are negotiated and agreed. On the rare occasions that the client wishes to buy the sole rights to your pictures, meaning that no one else can use it again elsewhere at any time, then the agency will contact you and ask your permission to sell the picture in this way. If you give them the go-ahead, they will negotiate a fee on your behalf and, because the picture immediately loses its sales potential, they will inevitably get you a very large fee. It's far more likely, however, that the client will wish to buy the right to use the picture just once in a particular way, after which he will return the original slide to the agency and it will go back on file to be sold again to a different client for a different use.

Once the sale has been agreed, the agency will take their commission, usually 50 per cent. That might seem unnecessarily high at first, but it's the percentage that all reputable agencies charge and, when you stop to think about it, it's not as high as it at first seems. The fact is that if your pictures are worth having, the agency will probably sell them many times over, and they only have to sell one picture twice to make up for the commission rate. On top of that is the fact that they will reach clients and markets you might never have found for yourself, making sales that you wouldn't have seen on your own anyway. Looked at in those terms, the 50 per cent they take begins to look quite reasonable. It's worth bearing in mind, however, that if you get really well known to the agency and you find they are making a lot of sales on your behalf, you might be able to negotiate a slightly more advantageous commission rate after a few years.

The money they earn for you won't be paid immediately they get it. Such an arrangement would be far too messy for the agency's books. Instead, it will be added to your account and paid in a lump sum to you at regular intervals, maybe every six months.

When you start to deal with an agency, you must think of it as a long-term investment and you must be prepared to work at it, to give the agency as many top-quality pictures as you can. It is not the best way for the new freelance to work, but for one who has been in the business for a few years and who is in a position to keep on turning out the right sort of material, an agency can be a very useful, lucrative and – ultimately – easy way to sell your pictures.

Photo Contests

The freelance photographer in search of ways to make money from his or her pictures has many avenues to explore. One that is often overlooked is the humble photographic competition. Somehow, it doesn't seem like 'real' freelancing, and yet not only can it often prove to be an easy way of getting your pictures published, it can also mean much higher rewards than you would get from normal reproduction rights.

There are photo contests almost everywhere you look these days. The most obvious place to begin is with the photographic press. Britain has more photo magazines than any other country in the world, and every one of them runs photo contests, most on a regular basis in every single issue. Apart from this obvious market, you'll also find competitions for your pictures in many other specialist publications – women's magazines, motoring magazines, nature

The picture that wins a photo contest must be a little different from the average, run-of-the-mill entry.

magazines, mother and baby magazines, etc., as well as the more general interest magazines like *TV Times* and *Weekend*. But markets don't end with magazines. You'll find contests launched alongside consumer products like cornflakes and soap powders, by professional bodies like the Sports Council, national newspapers such as the *Telegraph*, holiday companies and tour operators and even photographic suppliers and distributors. Keep your eyes open and you'll see contests for your pictures all around you. The prizes on offer range from cash to cruises, taking in a lot of photographic gear on the way. With just one picture, you could very easily win a luxury holiday or other goods worth over £1,000. There aren't many outlets for your pictures that could give you this sort of return for straight one-time reproduction rights.

Against these advantages, of course, you must set certain disadvantages that wouldn't normally be encountered in more straightforward publishing. The biggest of these is that you are actually in competition with other people to get your work accepted – and in quite a different way from the normal methods of acceptance. If you are asked to take a certain type of picture for private sale or for publication and it doesn't quite come up to scratch, it might remain the only easy option open to your client and so you will still make a sale. In a photo contest, you are up against a lot of other people, all trying to supply exactly what is required. Also a certain amount of luck can come into play. You might produce the best picture in the world, but if it is the type of picture that the judge doesn't like personally, he could easily throw it out, merely on the grounds of his own prejudice.

Things, however, are not as black as they seem, and it is actually a lot easier to win a photo contest than you might imagine. The big thing to remember is that the competition from other entrants isn't going to be as high as you might at first have thought. A few years ago, BFP Books, in publishing a book about winning photo contests, did a survey of photo contest judges of all types from local club judges, through to national and international judges. Among many questions put to the judges, perhaps the most pertinent was this: What percentage of pictures would you consider in any one contest is genuinely worth considering as a prize winner? Each judge was asked individually, yet all came up with the same sort of answer – five per cent.

Book publishers have a use for all sorts of people pictures, whether they are demonstrating some subject connected with the book, or whether, in the case of a photographic book, they are there to demonstrate some special photo technique.

So if 1,000 photographers enter a contest, no more than around 50 stand any real chance of winning. Add to this the fact that only a very small percentage of the people who *could* enter a contest actually get round to doing so (in a photo magazine, read by amateur and professional photographers, the figure is usually about two per cent of the circulation and as little as half a per cent of the overall readership), and you begin to see why your chances, as a

dedicated freelance photographer, are a lot better than you might ever have imagined.

The reason why more people don't enter photo contests is probably down to a combination of apathy and the fact that they don't have the information you are now reading. The reason why those who do enter fail to gain a place is really very simple: They don't try hard enough.

Having said that you only have to beat 50 in every 1,000 entrants, don't think that winning is downhill all the way. The fact is that, despite 95 per cent of the entries being unacceptable, that small five per cent will be good. Some of them will be very good indeed and, at the end of the day, it's that small percentage of superb pictures that you have to beat, many of which will have been supplied by 'professional' contest entrants – those familiar names that you see cropping up in the photo press time and time again. So don't think you don't have to be good. That's where most of the other entrants will fall down.

The vast majority of photo contests have a theme, and your first requirement is to make sure your pictures fit that theme. Since our subject is people, you're in with a good chance to start with, because people can be used as part of all sorts of different subject matter and also because human interest in any picture, when it is handled in the right way, will help a picture win a contest. There are, of course, certain photographic subjects which are totally unsuitable to the photographer who specialises in people pictures. You might get away with it if the subject is landscapes and you can include people as foreground interest, but if the subject is something like wildlife, then forget it and find another contest.

Having discovered that your brand of photography will fit in well with the theme of your chosen contest, really go out of your way to take a picture for that theme. If you have a good picture file and you can find one in it that really fits every requirement of the theme, then by all means use that, but by far the best way is to look at the theme, work out a picture that will suit it in your mind, then to go out and shoot specifically for the contest. Remember that the majority of entrants will be plucking pictures from their files, and if you want your entry to stand above theirs, you need to go one better.

Right at the start, read the rules very carefully. This is another area in which most entrants fall down. They only skim through the rules and so they miss important aspects. And if their pictures do not obey those rules, they'll be disqualified. If the rules specify certain sizes of picture, comply with them; if they ask for mono only or colour only, get it right; when they state a closing date, make sure your pictures are posted well on time. It's the little things like this that so many competition entrants fall down on.

Always look at things from the judge's viewpoint, not your own. Just because a picture might have been difficult to take, do not assume those difficulties will help you win the contest. Your entry will stand or fall by the picture itself, not by any difficulties involved in taking it. Remember that the judge is bound to have seen a lot of very ordinary pictures, so give him something different to look at. Assuming you have the right sort of competition and an appropriate picture for it that fits the theme, there are three very real ways in which you can grab a judge's attention and make him seriously consider your picture above all the others. Make it bold, give him quality and show imagination. Let's look at each of those in a little more detail.

Make your subject bold in the picture area. One of the biggest mistakes competition entrants make when photographing people is to shoot them from too far away and in a candid manner. Unless you are out to produce a candid picture as such, any person worth photographing is worth posing. So don't be afraid to make the

Whenever possible, shoot pictures specifically for certain photo contests. Think of a good idea, then try to improve on it before you even press the shutter.

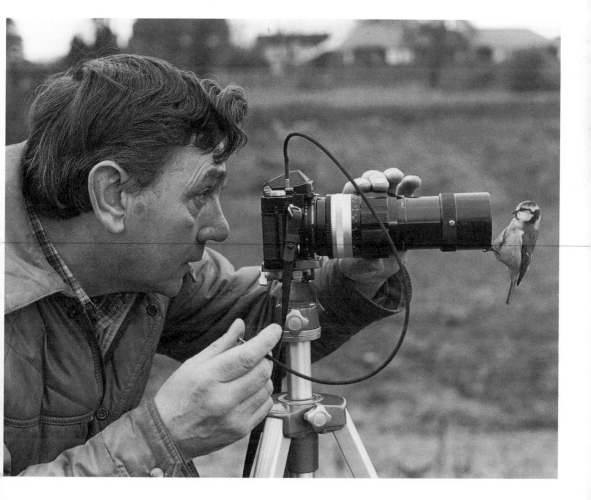

necessary approach. Get close to your subject, pose them in an attractive way and really fill the frame with the person concerned, together with any activity he or she is involved in and which is pertinent to the theme of the contest.

Only enter prints and slides of the highest quality. Do not submit pictures which are over or under-exposed especially if your entry is in the form of slides. A colour transparency can be slightly under-exposed, by around one-third or half-a-stop, but it should never be over-exposed. Black and white prints should be on glossy paper if the contest organisers are publishers who aim to print the winners, the print should show a good range of tones and it should not be covered in dust marks or scratches from sloppy printing.

Most of all, show a little imagination. When you sit down to think of a way to shoot a picture for a contest, look at the most obvious way of going about things and then discard it. That's the way the majority of entrants will tackle the subject. Look for a slightly more off-beat way of illustrating the theme. If such a way comes immediately to mind, there's a good chance it has also come to the mind of those other professional contest entrants – or at least a good proportion of that magic five per cent. So either throw that idea out completely, or take the basic idea and improve on it further.

Finally, a few words about the sort of contests to avoid. The majority of photographic competitions are organised for the benefit of the entrant while, at the same time, offering extra publicity to the organisers and sponsors. When your picture is chosen as a winner, the terms under which it is accepted are similar to those for the sale of any picture. In theory, the organisers or sponsors should pay you for publishing it. In practice, it's fair enough to accept that your prize is payment enough for their right to use it once. But only once. just because they have given you a valuable prize, worth maybe a couple of thousand pounds, don't assume they have the right to use your picture as many times as they like. That prize will already have been paid for in terms of publicity and you owe them nothing. So don't sign away the rights on your winning picture just because you happen to be overwhelmed by the prize.

Some contest organisers build this sort of thing into the rules claiming copyright on all winning entries – another excellent reason for reading the rules carefully before you enter. If you see a rule like that, then avoid the contest.

Worse still, a few organisers try to claim copyright on *all* entries, whether they were winners or not, which is even worse. just think of all the free pictures they get for their own use, and consider how you'd feel if you signed away the rights to some of your best pictures without even winning the contest anyway. So if you see a rule in the contest that says something like, *The copyright of all entries becomes the*

property of the organisers, forget it and find another contest. Likewise, most rules should contain a line that actually states that the copyright of all entries remains with the entrants.

If you'd like to learn more about this, together with a lot more information on what goes on behind the scenes in national photographic competitions, read *Make Your Pictures Win*, published by BFP Books.

A Final Check

By now, assuming you've read and absorbed the foregoing chapters, you should be in a good position to start shooting and selling pictures of people. So you find your market, you parcel up your pictures and you send them off. A short while later, they come back with a rejection slip. What went wrong?

Your pictures will have been rejected for one of two reasons. They might be perfectly okay as far as the market is concerned, but the publication may have been forced to return them simply because they are over-stocked with similar material. If that's the case, you need only find another, similar market, adapt your pictures according to its particular needs and try again. Perhaps a more likely reason for rejection – and one that you won't be as happy about – is the fact that your pictures just were not good enough for the market you chose or, worse still, for any other market. Rejection slips come fast and furiously when you first set out to freelance and you must not be put off by them. Equally, you should not ignore them, thinking that the editor is wrong rather than you. Always be prepared to admit that you are the one who is in the wrong and use the rejections to analyse your mistakes. Don't be disheartened by rejection of your work, but try to learn by it instead.

Here's a ten-point check list of common mistakes made by freelances. Check your rejected pictures against it to see if you can discover where you went wrong. Be totally honest with yourself. Don't try to pretend your pictures are better than they really are. You might kid yourself, but you won't kid an editor, and he's the man who counts in this business.

Better still, check your work against the list *before* you send it off. That way, you stand a better chance of giving your editor exactly what he wants in the first place. And that is the only real way to success.

1. REQUIREMENTS

Has your picture fulfilled the market requirements exactly? Is it really the sort of subject you have seen published by this particular market in the past? Were you really thinking about this market at the time you took the picture, or is this just a picture from your files

that you have tried to adapt to the market? If so, have you really succeeded, or is the final result only an approximation of the actual market requirement? Is there anything you could have done at the time you took the picture to improve it or to angle it more towards your chosen market?

2. PURPOSE

In order to sell, your pictures must have a very real sense of purpose. They should preferably show the readers something they cannot easily see for themselves, or something about the chosen subject that they might not otherwise have considered. So, while the pictures must be of the type that is continually used by the publication, their actual content should show something a little different from the usual run-of-the-mill subjects. That difference can take the form of a straight shot of an unusual subject, or maybe a straight subject shot in an unusual way. Either way, it will be different. So, do your pictures have a sense of purpose and are they different?

3. COLOUR OR MONO

Some markets are exclusively for colour, others only for mono. Do your pictures comply with those requirements? If the pictures are colour, are they in the form of transparencies? If the market uses a mixture of both colour and mono, it's probable that the colour editorial content is smaller than the mono content, giving you a better chance of success with black and white prints. Are you reducing your chances by sending coloured pictures of subjects that would work just as well in mono?

4. PICTURE SIZE

Are your mono prints the right size? The ideal is 10 × 8 inch, printed on glossy paper. You might get away with 7 × 5 inch, but trade-processed black and white enprints will ruin your chances. What about colour? Does your market specify minimum transparency sizes? Sending 35mm to markets which specify a minimum of medium format or even larger will guarantee rejection. Even markets that claim to merely *prefer* medium and large format to 35mm are sometimes worth ignoring if you are restricted to the smaller format.

5. QUALITY

Is the quality of your pictures right for reproduction? Are your transparencies perfectly exposed? A little under-exposure (no more than one-third or half-a-stop) will get by, but over-exposure will be rejected every time. What about your black and white prints? Do they have a full range of tones? Flat, grey prints will be rejected.

Are they free of dust marks and scratches? Were the original negatives correctly exposed and are you giving the correct amount of development time to the print?

6. STUDIO WORK

A major part of this type of photography takes place in a studio. If your pictures were taken either in a professional or make-shift studio, do they meet the necessary requirements for publication? Is your model genuinely attractive? Does she know how to pose naturally, or do the pictures show a lot of tense expressions, with the model obviously waiting for the shutter to click? Is the lighting right? Is it soft and evenly balanced, or is the face full of ugly, contrasty shadows?

7. FILLING THE FRAME

Did you take a bold enough approach when you were taking the pictures? Have you moved in close and filled the frame with your subject to show the person concerned to their best? Did you take the pictures candidly from too great a distance, when posing the subject specifically for the camera and taking a closer viewpoint would have produced a better result?

8. GENERAL COMPOSITION

How's your picture composition? Does it match up to the requirements of your particular publication? If you were shooting cover pictures, have you left room at the top and sides for the magazine's logo and coverlines? How is your subject placed in relation to the background? Is the background itself a major part of the picture or does it form an unnecessary and irrelevant distraction behind the subject?

9. PRESENTATION

Is your work presented in the best way? Are prints packed in stiff envelopes to prevent them becoming dog-eared at the edges? Are they captioned correctly with a typewritten caption attached for easy removal? Have you written on the back of prints with felt-tip pen, and if so has the ink from the back of one print transferred to the front of another? Are transparencies presented in plastic filing sheets? Are they easy to view? Is your packaging secure, yet easy to open? Have you written a brief and to-the-point letter to accompany your pictures, or does it ramble with excuses for inferior work?

10. GIVE THE BEST

Finally, one question that sums up all that has gone before. Quite simply, can you lay your hand on your heart and honestly tell

yourself that the pictures you are trying to sell really are your best work? Look at them completely objectively, the way a stranger might. If you feel they could have been better, don't be afraid to admit it. There really is little point in telling yourself your work is better than it really is, because as much as you might fool yourself, you'll never fool the editor who opens your envelope and looks at your pictures for the first time. Only when you put yourself in his shoes and see things through his eyes will you start to make serious picture sales.

The Pictures

WHO TOOK THEM AND WHERE THEY SOLD

The Pictures
WHO TOOK THEM AND WHERE THEY SOLD

Many of the pictures in this book may be familiar to you. We make no apologies for this; one of the main functions of the book is to help you produce saleable pictures. How better to do this than by showing actual examples of pictures that have sold? Below we give further details of the pictures – who took them and exactly where they sold.

Page No:	Photographer:	The markets:
Cover	John Wade	Private sale to hairdresser Photo magazine cover Two photo magazines as article illustrations National photo contest winner
8	Chris Lees	Photo magazine as article illustration Model's portfolio
9	John Wade	Two photo magazines as article illustrations
11	Ian Weightman	Athletic magazine
12	Nick Kidd	Ilford Photographic Awards winner
14	John Wade	Photo magazine as article illustration
20	Alan McFaden	Photo magazine as article illustration
22	John Wade	Photo magazine as article illustration
25	John Wade	Filter manufacturer's catalogue Photo magazine article illustration
28	John Tracy	Mother and baby publication Private sale to parents

Page No:	Photographer:	The markets:
30	Raymond Lea	Local newspaper Photo magazines
31	John Tracy	Photo magazine files
32	Ralph Medland	Model's portfolio Photo magazines as article illustrations Calendar
35	John Wade	General interest magazine Mother and baby publication Photo magazine as article illustration
37	John Wade	Two photo magazines as article illustrations
39	John Tracy	Travel press
41	David Hugill	Local newspaper Grocery trade magazine County magazine Photo magazine
42	Stephen Coe Studio	Ilford Photographic Awards winner
43	Chris Lees	Model's portfolio Photo magazine as article illustration
44	Jeffery Whitelaw	Photo magazine Calendar Several county magazines Religious press
47	Alan McFaden	Photo magazine as article illustration
48 (left)	Chris Lees	Photo magazine for files
48 (right)	John Wade	Two photo magazines as article illustrations Book on photographic technique
49	Andrew Crowley	Ilford Photographic Awards winner

Page No:	Photographer:	The markets:
50	John Wade	Private sale to model Local photo contest winner Two photo magazines as article illustrations Books on photographic technique
52	John Wade	Two photo magazines as article illustrations Book on photo technique
53	Brian Sutton	Four photo magazines for file and article illustrations
54	Dennis Mansell	National newspaper Farming magazine Countryside magazine Photo book Many foreign sales
56–57	John Wade	Photo magazine as article illustration
58–59	John Wade	Two photo magazines as article illustrations
60	Nigel Holmes	Cover for disco magazine Book illustration
62	Nigel Holmes	Cover (in colour) for photo magazine
63	John Tracy	Photo magazine files
65	Dennis Mansell	Photo magazines for files Multiple sales in Britain and America
66	Manny Cefai	Craft magazine
69	Peter Titmuss	Photo magazine contest winner Book illustration
83	John Howard	Local press Photo magazine as article illustration Private sale to subject
89	Chris Lees	Private sale to subject Photo press as article illustration

Page No:	Photographer:	The markets:
91	David Hugill	Local press Photo magazine as article illustration
92	David Hugill	Local press Photo magazine as article illustration
94	Glyn Jones	Local press
96	Ken Lennox	Ilford Photographic Awards winner
97	Philip Dunn	Ilford Photographic Awards winner National newspaper
98	Nigel Holmes	National newspaper General interest magazine Book illustration Model's index card
101	Manny Cefai	Craft and hobby magazine
102	Tony Boxall	Holiday magazine
103	John Wade	Women's press Photo magazine as article illustration
105	Nigel Holmes	Cover for photo magazine (in colour) Book illustration
106	John Wade	Women's press Photo magazine as article illustration
107	David Mansell	Photo press as one-off illustration
108	Jeremy Burgess	Photo press for file Farming magazine
110	Tony Boxall	Photo contest winner Photo magazine for file use
113	John Wade	Angling magazine Women's press Photo magazine as article illustration Book on photo technique